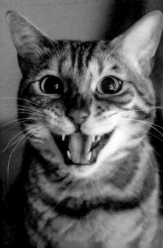

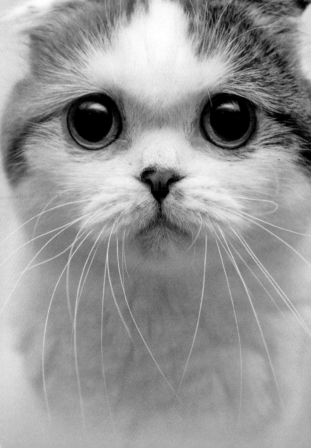

HOW TO TAKE

AWESOME PHOTOS OF CATS

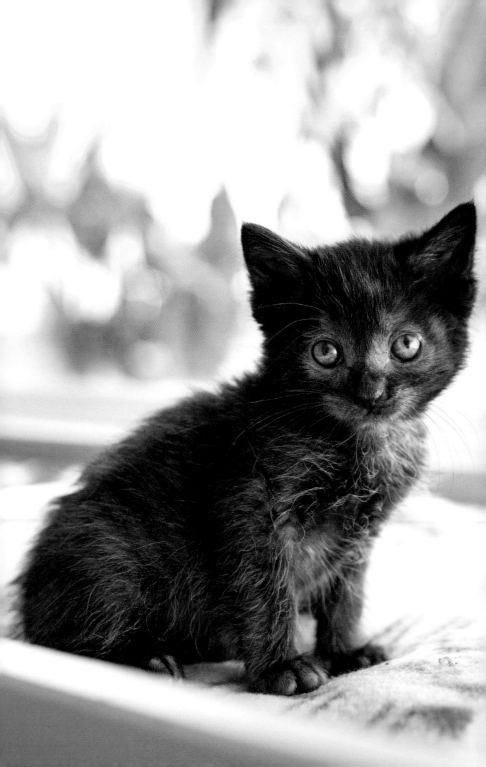

HOW TO TAKE

AWESOME PHOTOS OF CATS

ANDREW MARTTILA

RUNNING PRESS
PHILADELPHIA

Running Press
Hachette Book Group
1290 Avenue of the Americas, New York, NY 10104
www.runningpress.com
@Running_Press

Printed in China

First Edition: May 2020

Published by Running Press, an imprint of Perseus Books, LLC, a subsidiary of Hachette Book Group, Inc. The Running Press name and logo is a trademark of the Hachette Book Group.

The Hachette Speakers Bureau provides a wide range of authors for speaking events. To find out more, go to www.hachettespeakersbureau.com or call (866) 376-6591.

The publisher is not responsible for websites (or their content) that are not owned by the publisher.

Print book cover and interior design by Joshua McDonnell

Library of Congress Control Number: 2019948457

ISBNs: 978-0-7624-9515-3 (hardcover), 978-0-7624-685-9-1 (ebook)

1010

10 9 8 7 6 5 4 3 2

For Jumbo

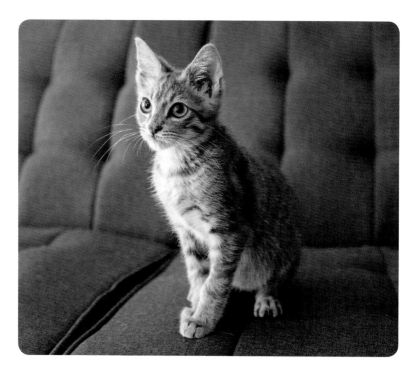

CONTENTS

INTRODUCTION

Hi, everyone! My name is Andrew, and I'm a cat photographer. I'm betting you picked up this book, leafed through some of the pages, and thought, "Wow. This is weird, but really cute . . . and potentially useful for my own photos of Fluffy." Welcome! In this wild world where cat photos dominate the internet, I'm honored to be your guide. I hope that the time we spend together will be valuable, and that by the end of the book you'll see a marked change in the photos you take.

Personally, I think everyone ought to contribute to the everlasting fountain of feline photos on our feeds, but my goal is to elevate your photos to the next level. While it may be perfectly evident to you that Fluffy deserves a vast audience to appreciate every last whisker on her face (including the ones with leftover bits of breakfast), images are easily lost to the internet shuffle. It's time to make your photos stand out from the crowd.

As for me, I've been taking pictures of cats for almost a decade. Surprisingly, for a self-confessed cat guy, it wasn't until later in life that I got my first cat. I grew up terribly allergic to animals and couldn't have traditional pets around the house. After living around a family member's cat for some time in my early 20s (inhaler in hand, of course), I developed a tolerance to cats and felt comfortable taking the plunge into cat fatherhood. So, I got my first cat in 2010; a Bengal named Haroun.

From the get-go, Haroun was incredibly sweet and photogenic. Unfortunately, I didn't have a decent camera to capture him, nor the

know-how to use one. I tried my best to take shots of him with a phone, but there were obvious limitations, especially with the technology from 10 years ago. My roommate at the time had a professional camera, and I asked him if I could borrow it for a few trial shots on my cat. And that, my friends, was the beginning of my journey to becoming a professional cat photographer.

When I first started taking photos of my cat, I was absolutely clueless. I looked around on the internet for guides, and while there was a plethora of photography tutorials online and in print, unsurprisingly, very few applied to animals. And, believe it or not, even fewer to cats. I began by learning general information about cameras and then read up on the basic principles of photography, especially portraiture and the use of light.

It became clear that if I was to move forward, I was going to have to figure out a lot of the specifics on my own—the vast majority of which would take place through trial and error. Like most acquired skills, we can look back and laugh at our first attempts. In fact, my social media posts are a testament to slow and gradual progress; the images from the beginning of my photo-taking days are a minefield of missteps and errors. But I improved. And, for better or worse, the evolution is painstakingly documented online.

What began as a hobby slowly morphed into a part-time job. I gained some recognition on social media at a time when taking photos with a real camera stood out from the sea of blurry, low-resolution phone photos. In my last year of college, I created a website, plastered some flyers around town, and began taking my first clients as a pet photographer. The majority of shoots started with family and friends, and god bless them for paying real money for those amateur photo sets.

It ended up helping me out more than they knew. Those initial sessions built my portfolio and boosted my confidence. After college, I stepped away from continued studies in the field of neuroscience to pursue pet photography full time. Since committing what my parents

at one time considered a "grave mistake," I've taken pictures of literally thousands of felines all around the world.

To date, I have published two books filled to the brim with cat photos: *Cats on Catnip* and *Shop Cats of New York*. My photos have been featured in numerous galleries and covered by major news outlets both online and in print. I've even appeared live on national television to talk about my cat photos. Most of you will probably know me from the internet. Say hi on Instagram @iamthecatphotographer. My partner Hannah Shaw (aka Kitten Lady) and I even have a nonprofit organization called Orphan Kitten Club. In the book you're bound to see, and maybe even recognize, a bunch of the kittens we have rescued. Yup, it's fair to say cats are (a big part of) my life.

In 2018, I started giving photography workshops at cat conventions all across North America. I've done a bunch of them now, but I used to be genuinely petrified by the idea of public speaking. The first talk I gave in New York City was in front of a few hundred people in a big conference hall. I had a lump in my throat the entire time. I was sweating. I was mumbling. I felt as if my words were virtually incoherent, but I did it. And I did it because I felt it was necessary to put my fears aside so that I could be of assistance to others. By others, I don't mean people—I mean the cats!

Sure, it's important to help amateur photographers get a better understanding of their craft. It's also satisfying to explain how smartphone users can create lasting memories with their devices. But what has been most valuable has been teaching photography to those who work with or volunteer at animal shelters. I truly believe that by enabling people to take better photos of adoptable animals, the likelihood of those animals leaving the shelter system skyrockets.

In the upcoming pages, I'm going to spill all my photography knowledge and secrets in what I hope will be an approachable, easy-to-understand way. I want you guys to be able to read an actionable tip, put down the book, apply it, and (pending your cat's cooperation)

see immediate results. As you may have gleaned from my short bio, I'm not classically trained in photography, which means I'm going to break everything down in really straightforward terms.

Some concepts may come much more intuitively to you than others, but don't be discouraged by those that take a bit longer to sink in. If everything clicks immediately, that's awesome, but I will still encourage you to build on the ideas presented here and experiment with settings until you come up with what looks and feels right to you. This book is full of rough guidelines on how to land a successful shot, but your end result might look considerably different from mine and that's totally okay.

Many of the principles we cover are basic and apply to photography in general, but we'll also get into some nitty-gritty stuff for those who have or are interested in professional, or what I like to call dedicated, cameras. I tend to differentiate these from smartphone cameras with the name "dedicated" because these devices serve no other purpose than to take photos. There's also an entire chapter on phone photography for those who primarily shoot with smartphones.

Near the end, we'll cover editing and what to do with your new-found skills and beautiful shots once you've become a maestro. But before we even pick up the camera, we're going to have to learn a bit about cat behavior. Remember: Every cat is a unique individual with their very own idiosyncrasies, so their interest and cooperation will definitely vary. However, with my guidance, you'll be snapping beautiful shots worthy of framing and sharing on social media in no time! Lastly, be sure to tag your cat photos with #AwesomePhotosOfCats so we can all learn from each other—and drool over cat photos, of course. Let's get to it.

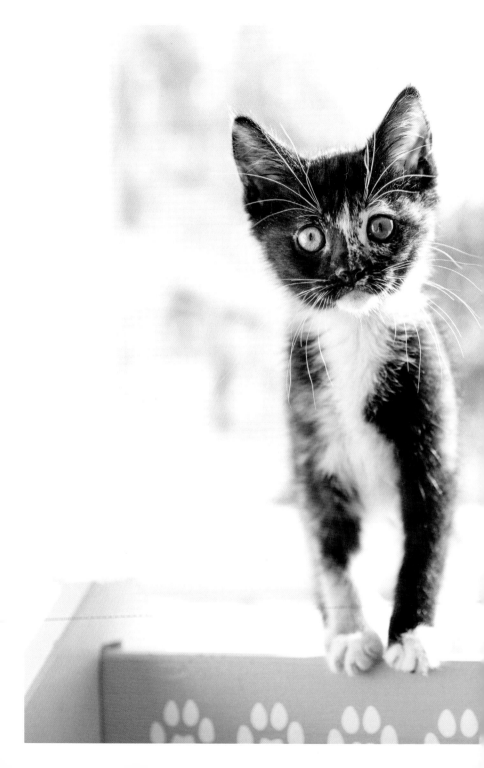

Chapter 1

Our Very Special Subject

Cat photography isn't easy. If it were, I don't think I'd be in business, and I certainly wouldn't have the opportunity to write a book on the subject. It's hard. So, right out of the gate, I want to do a quick exercise with you. Let's begin our foray into the world of cat photography by taking a collective deep breath. Hold it in. Count down from five. Now, as we exhale, let's drastically lower our expectations several notches. Once more. *Ahhh!* That feels good, doesn't it?

Expecting perfect shots with every click of the shutter is a fast and easy way to become disheartened. No one takes perfect photos all the time. So let's not anticipate that every shot is going to win Nat Geo's photograph of the year. Instead, let's set our sights on getting a handful of reasonably clear, engaging photos within every set we take. As we get better, the ratio between usable photos and shots destined for the trash can will grow in our favor, but it remains crucial to be realistic. We can do everything right mechanically and yet still not get what we're after.

If we want a baseline opportunity to get decent shots, what must come first is a rudimentary understanding of feline behavior and how best to achieve the optimal outcome for both parties. It's super critical to keep in mind the well-being of the cat as we're taking photos. Animals are not props! They are incredibly complex, emotional beings and deserve to be treated as such. If we find that they're becoming stressed, aggressive, or avoidant, we might want to reconsider our approach. And to maximize the quality time with our feline subject, it is paramount to set the tone for the shoot properly.

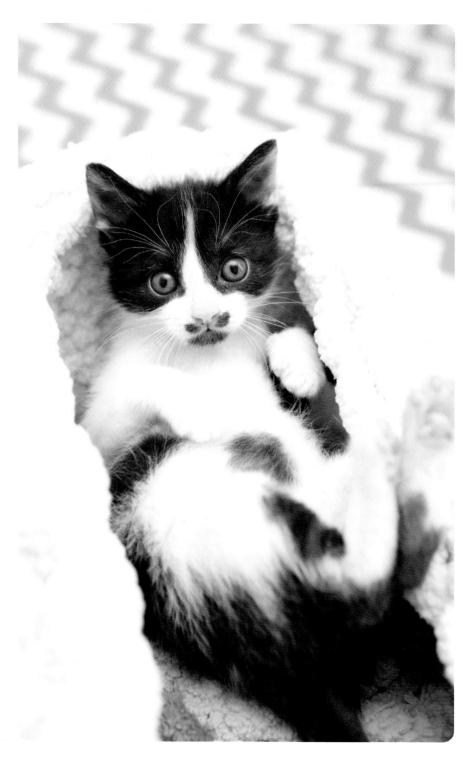

SETTING THE TONE

When I show up to a new shoot or go to an animal shelter to do volunteer photography, I always spend a generous portion of the visit gently introducing myself to all the subjects. The introductory period always comes first. Cats are creatures of habit and they're often apprehensive around new people, so it's best to leave your equipment tucked away while you get to know them. A good acclimation process involves soft, encouraging speech; hand extensions to allow scent swapping; treats; and sometimes even a pinch of catnip.

The pacing of your shoot will largely be dictated by the cat's willingness to interact with you. You may end up spending more time hanging with the cat than behind the camera, and that's okay. Getting a few choice photos of a comfortable cat is far more valuable than a lengthy set of a visibly uneasy cat. And, to be honest, the goal of all my shoots is to befriend the cats; the photos are just a bonus.

To allow a cat's unique personality to shine in photo form, we're going to want them to be as comfortable around us and our equipment as possible. If you're photographing your own cat (which is likely the case for most of you), then you probably don't need to spend quite as much time getting your cat to act naturally around you. You may, however, have to get your cat used to your equipment.

In the animal world, anything unfamiliar may be considered threatening. While you may be fully aware of your harmless intentions to take snapshots, that certainly doesn't mean that your cat is. I take the trash out every week, and when I change the bags, my cat always looks at me like, "Ahhh, so today's the day you're going to try to kill me, eh?" and

runs off with the swiftness. The sounds that cameras make can be startling, not to mention the lights that they give off if you're using a flash.

If I find that the cat is deeply unsettled by the mere sight of my camera, I'll place it down on the floor closer to them and step back. This allows them to check it out more thoroughly and hopefully realize that it's not a threat. Sometimes this is all it takes. In cases where you're doing a shoot with an unfamiliar cat, I cannot stress enough the importance of proper pacing. Employing patience during this part alone will make a massive difference in the experience for both of you.

The time frame in which a cat becomes comfortable around you can range from moments to hours, to days, to years. Some cats will immediately hop in your lap, smush their face into your face, and drool all over you. Others will avoid you by tearing a hole in the bottom of a couch and camping out inside until you leave. True story. Don't be too discouraged if they end up being a bit wary of you at first. Take your time! Especially in cases of shelter photography, our goal is just to get a very basic, usable photo highlighting their personality. We'll want to try to showcase them in the most positive, inviting way, so never be too aggressive in your approach to get the "perfect" shot. That's a surefire way to sour the shoot.

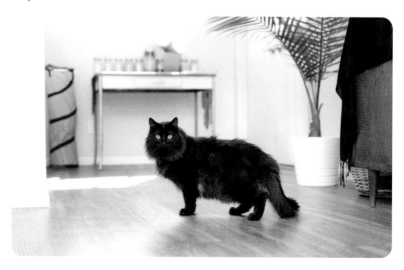

READY OR NOT?

One of the first things we have to gauge is the cat's willingness to participate. We can assess their behavior with some basic criteria:

- Are their ears pointed back?

- What sounds are they making?

- Is their tail moving about normally, pointed upward, or swishing fiercely with a vengeance?

- What's their posture like?

All these questions will play a pivotal role in figuring out our next move. Some of the best indicators of their mood come from looking at their ears, tail, and body. There's a broad spectrum when it comes to cats, but for our purposes, we'll think about it in terms of the following continuum:

ANXIOUS ——— CONTENT ——— AGGRESSIVE

Tails

Anxious—Whenever my cat goes to the vet, I can always expect to see his tail tucked low to his body, between his back legs. The saying, "He came back with his tail between his legs" is so true! A bummed or fearful cat will often put their tail away in an effort to appear smaller or less threatening.

Content—A content cat's tail will be still, or swaying slightly. It won't be poofed out more than usual and will have a steady rhythm to its movements.

Aggressive—If you see a cat flicking their tail with vigor, this means war. Watch out! Our cat Eloise will always let me know with a few flicks of the tail before she decides to correct me with her claws. You may also see their tail grow to two times its standard thickness. This is a natural defense mechanism to ward off threats by making them appear larger than they actually are. They might not be poised to attack, but they're warning you that they find you threatening.

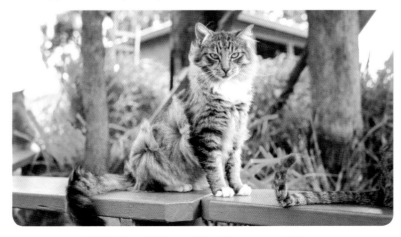

A lightly swishing tail is always a good sign.

Body

Anxious—Similar to the tail, a cat who's upset will slink extremely low to the ground. They will often flatten themselves and try to tuck all their limbs underneath themselves, minimizing their appearance.

Content—A happy cat looks confident. They'll look at you, approach you, and have a fairly linear arch in their back.

Aggressive—This is what we like to call Halloween Cat, because if you've ever seen the imagery of a black cat with an arched back and a poofed-out tail that's ubiquitous around the October holiday, then you already know what an aggressive cat looks like. This guy is the embodiment of fight or flight. Aggressive cats will often turn to their side and fluff out their fur to look much more substantial and scarier than normal. If a cat turns its side to you and does this, they're really spooked and might be willing to do something about it.

Ears

For ears, it's really simple. If you see them flat and almost pasted to their head, they're not happy with the situation.

She's cute but she's clearly not into you.

This is a warning sign to back off. They might not necessarily be ready to attack, but they're letting you know that what you're doing is upsetting them. Keep in mind that this is a very different look from "airplane ears," whereby the cat is just homing in on the location of a sound.

Ah, the look of annoyance and disappointment rolled into one.

Generally speaking, it's best not to photograph a distressed cat, even if they're your own. It might be funny to get a novelty shot of your own cat hissing, but if it's a client's cat or a shelter animal, the client or shelter managers will be decidedly less than thrilled that you have upset their animal. Cats can be extremely emotional beings and if their only shelter shot is of them with their ears down, back arched, and hissing, they're really not going to fare well when people are perusing the adoptable cats section online.

HOW TO PET A CAT

This seems like a no-brainer, right? But the sheer number of people who simply don't know how to properly stroke their feline overlords is astonishing! Being able to scratch the right spots can be the determining factor between creating a mortal enemy and a bff4ever.

Consult the image:

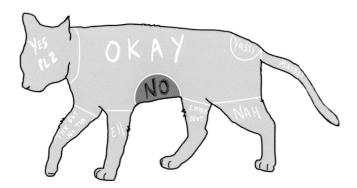

I'd like to think you know how to pet your own cat, so I won't go into a whole lot of detail here. You probably know where they like to be touched and where they don't. These are broad guidelines, so don't @ me if your cat loves to have their belly rubbed and toe beans massaged. That's great, but don't expect the neighborhood cat to follow the same rules. The undercarriage of a cat is where all their vital organs are, so it makes sense that they would be evolutionarily predisposed to have caution signs strewn all over it.

Also, unless you know the cat really, really well, *never* try to pick them up. That's an excellent way to catch some fresh red DIY cattoos on

your body, unless, of course, you're into that sort of thing. Just imagine how you'd react if you were at home sitting on the couch, minding your own business, and a stranger entered your house and hoisted you up by your armpits. You'd probably have a strong inclination to bop them on the nose. Same applies here.

For unfamiliar cats, start by extending your whole hand, fingers facing down so that your knuckles are exposed, almost like an unclenched fist. If, for whatever reason, the cat is keen on biting you, this method will also work as a safeguard. They'll have a much harder time finding purchase on your knuckles than if you were to extend your hand palm up, fingers spread. Let them smell your hands. They might even swipe their cheeks on your hands. If they're into it after the first sniff, you can try your luck by extending a single finger for them to check out. This will often be met by their nose, similar to how cats introduce themselves to one another. I'm not going to tell you not to boop the nose, but if you do, know the risks. The temptation is real.

Now, let the cat smell you! Cats have an extraordinary olfactory system, and, as is customary with most animals, you need to pass a quick "background check" before they permit you to hang. After they catch a whiff, as long as they're not growling or in an anxious or aggressive position, I move immediately for the top of the head or the cheeks. Cats have several scent glands where they not only release some of their own specific markers, but they absorb others' scents, too. **The areas we're going for are here.** ·

The cheeks are a great initial target because the cats are able to track your movements head-on and can very quickly give you corrective feedback. If you get some solid scritchins in on the face, try moving up to the top of their head, their ears, and then down the spine to just above the tail. For the right cat, this is prime real estate. Aside from those spots, everything else is a gamble. Again, I highly discourage you from exploring too much, especially if you're dealing with an unfamiliar cat.

Lastly, if your cat is anything like mine, you may have noticed that they typically vacillate between berserk disco-dancing and sleeping so soundly that they often require a prodding finger to check their vitals. While either end of the spectrum can offer some great photos, we're going to be seeking that middle ground where they're alert and playful, but not climbing the walls. Our calm, patient disposition can go a long way to ensuring that the tone is kept in the optimal range for the shoot.

Each marker is a sweet spot for petting!

CATS DGAF (DON'T GIVE A FLUFF): AN EXPLORATION OF ALOOFNESS

So we're in: The cat has accepted us as one of their own and is keen on pets, pats, and scritches. Their guard is down, but now their total indifference to the camera is showing. Do you know why cats have so many muscles in their ears? To better ignore us. No, seriously. Whereas dogs will sit, roll over, and bark on command, cats not only march to the beat of a different drum, but to an entirely different instrument. Fortunately, we can utilize their natural instincts to draw their attention. It's entirely possible to get a cat to stay still, pay attention, and look longingly into the camera by using a couple of key techniques. These techniques require two things: toys and a creative voice box.

THE TOYS ARE BACK IN TOWN!

Toys, you. You, toys. It has been an absolute pleasure to introduce you two, and I hope you'll become the best of friends! Toys are going to be invaluable in your quest for the best cat pics. They're my go-to when snapping photos, but in a slightly more unorthodox way than you might think. I like to consider the playtime I allow between the cats and toys as heavily supervised visits.

I'm actually pretty stingy during a shoot and won't often let my subject play with the toy until after I'm done taking photos. The toys are usually kept just out of reach and used as a means to build anticipation and maintain attention. Some of my favorite toys are also those that make noise. Exciting two senses at once will double your chances of getting your cat to pause for a moment so you can get the shot.

To do this properly, we're going to need to train ourselves to become comfortable taking photos with only one hand. This can prove to be pretty tricky initially, especially if you have a larger dedicated camera, but it is an essential skill that you'll want to perfect as time goes on. Unless you have an assistant (which is an unlikely luxury to have), learning how to shoot one-handed will make your life a lot easier in the long run. This way, you'll be able to use your empty hand to distract and call your cat's attention with toys.

Wands

Wands come equipped with either a long, colorful fabric strip or a string with feathers at the end. You'll find that many wands, especially the feather type, have several tiny bells. These are incredible for getting your cat into play mode and snapping their attention. When using wands with fabric, you'll want to mimic the movement of prey: quickly sliding them along the ground, staggering their movements unpredictably, and hovering them around the cat's height. This is the best way to get them to engage.

Also, try playing with the toy so that it becomes hidden or obscured behind other objects, out of the cat's line of sight. You'll find out why this is so important shortly! One thing to keep in mind is that wand toys can be long, so for ease of use, we'll want to modify ours by either cutting the rod handle in half or tying up the excess string. Before you know it you'll be able to take photos just like this:

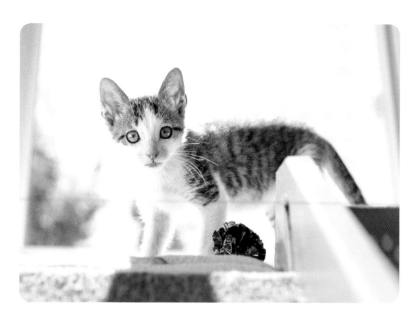

Crinkle Balls

These are primarily effective as an audio source, but some cats are extremely captivated by the visual and kinesthetic qualities of crinkle balls. The way I utilize them is mainly through audio cues. Waving the ball around while crunching it to produce sound will work surprisingly well to grab your cat's attention. You can then move the ball into a different spot, crunch it, and you'll notice the cat's attention follows. I absolutely love crinkle balls as a means to quickly "snap" attention, and they're really lightweight and easy to manipulate for the photographer.

I'll also lump the small plastic balls with bells and fabric mice toys with rattles into this section. Any little cat toy that also makes noise (which is most of them) can be easily gripped in your free hand and used in this manner. I just find that crinkle balls give you the most flexibility because you largely determine when the toy makes noise. Wow, never thought I'd write a paragraph about the acoustics of crinkle balls versus fabric mice, but here we are.

Laser Pointers

This is an important one to cover because cats and laser pointers are a pretty solid match made in heaven. That said, I wouldn't recommend it over the other toys for a few reasons. If you're just playing with your cat, I think it's totally fine. But if you're using it as a photography aid, you may run into complications.

First off, it's not an easy thing to manipulate, especially if you're looking through a viewfinder. Even if you can manage it easily, it's a toy best used when chased around a room and is most visible on walls. You'll end up getting the backside of your cat more than the front, and they'll often be farther away from your vantage point than if they were trying to play with a toy in your hand. Another issue is that they don't make sound, which has been shown to be extremely important to preserve attention. Also, even if you're able to get a great shot of your cat playing with the laser pointer, they don't really show up that well in photos unless they're heavily edited.

You can also go a nontraditional route. Some cats absolutely love things that aren't actually a toy at all. One of my cats has a penchant for plastic wrapping. I've met another who adores the little plastic bit that comes off milk jugs. I trust you to be a good cat parent and know what works best to engage your cat and get them to pay attention to you.

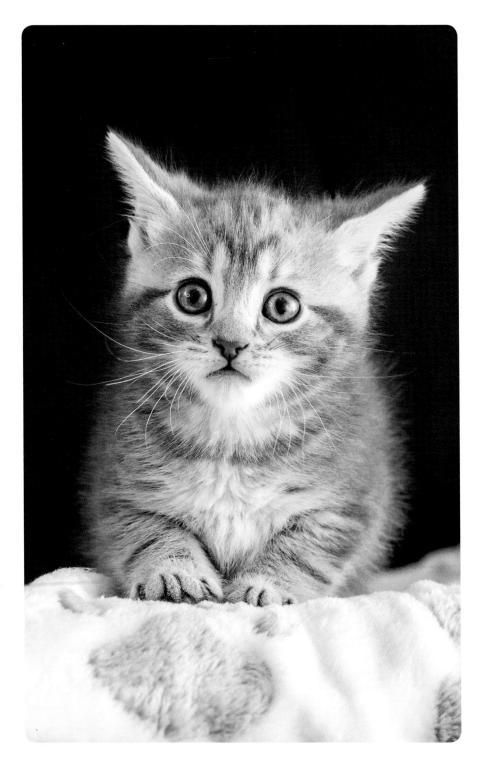

Sounds

Oh, boy. Whenever I do a live, in-person workshop, covering this section is the most awkward part by far. Utilizing the sounds you can make with your mouth will enable you to go into a situation empty-handed and still get the shot. "Psst pssst, here kitty kitty" will only get you so far these days, especially if your cat is a jaded veteran to catcalls.

With my cats, I really have to pull out all the stops to produce a sound that they've never heard before and is sufficiently interesting to snap their attention. Imagine what a porpoise receiving a tabasco enema would sound like. Throw in some trills and a few more additional high-pitched notes, and you're golden. It sounds a lot like what you'd hear if you yodeled into a blender.

Your cat will totally judge you for what you just conjured, but did you get them to stay still long enough to get a good shot? Boom. Worth it.

THE IMPORTANCE OF EYE CONTACT

Now that we've learned how to get the cat's attention for at least a milli-second, we can move on to one of my most frequently asked questions, which is this: "How do you get your cats to look at you/into the lens?!" Perfecting eye contact is incredibly important because a cat looking into the lens helps to create an instant, emotional connection with the audience. Eye contact is evocative. It's what causes butterflies in the stomach or activates the fight-or-flight response. In our case, let's hope it's the former.

With toys, achieving eye contact with the lens is so much easier than you would think. Imagine, if you will, attending a magic show where an adept sleight-of-hand magician is performing. As time goes on, you become fully engrossed by the magician. Unconsciously, your eyes go where they choose to send your attention, even if you're trying to fig-ure out their tricks and uncover their secrets. The next thing you know, the object in their hand you had been carefully following has vanished and appears inside a glass bottle on the other side of the stage. Claps! Bravo! Job well done. That's going to be us. Cat magicians. Well, sort of. We do have a wand after all . . .

Not only are magicians fully aware of how best to grab and main-tain their audience's attention, but they know how to divert it at the precise moment they're performing the trick. They possess a skill we want, which is the art of distraction.

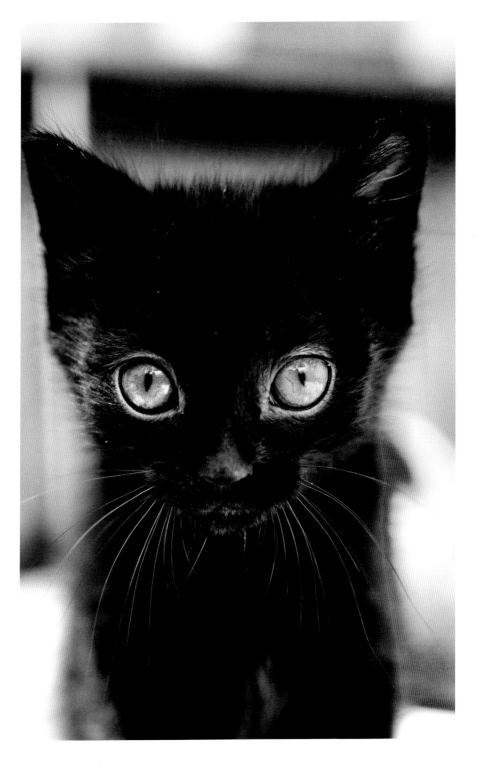

Start off small with a crinkle ball. Toss it around, crunch it in your free hand, and wave it in front of your cat so that their eyes lock onto it. Continue to shake it around, ensuring that their focus is dialed in carefully on your hand. Now for the "trick" part—while continuing to crunch the ball, place it behind the camera, which is being held by your other hand, ready to fire. As soon as you put the ball behind your camera, you'll notice that your cat continues to look for the toy and follow its sound. They will gaze directly at your device. Now's your chance. Snap the photo!

Rinse/repeat as many times as it takes to get the shot. Much easier than you thought it would be, right? If they're not following it behind the device, you can also place the toy on top of it, as opposed to behind it. You'll get a very similar effect.

The weird mouth sounds won't prove to be quite as useful at getting them to look into the lens, but there are a few other notable tips I can give you. If you're lying flat on the ground and your cat is positioned in front of you, shuffle your legs around and stomp your feet on the ground. They'll look at the source of the sound, which is positioned behind you and your device. Another simple method is to rattle the lens with your fingernails, or, if you're a phone user, the back of your phone case. Just expect their interest to drop off much sooner than if you were playing with a toy.

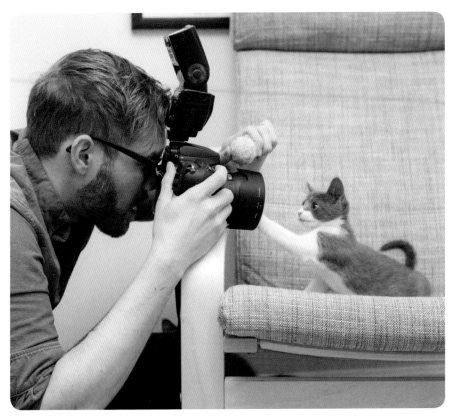

Keep your eye on the ball, Small Fry.

ASSUME
THE POSITION

We're going to be discussing perspective a bit in this book and how different angles can be used to our advantage when taking photos. Although we can slightly adjust angles afterward, while editing in post-production, a critical factor in getting stunning shots is to ASSUME THE POSITION. It's going to be tempting to take photos as though we were taking pictures of anything else—standing up, with a straight line out or down from your line of sight. Cats are predominantly ground roamers, so if we were to follow a traditional shooting method, our photos would only come from a top-down perspective.

Photos like this are not unique. Why? Because it's how we view the world at almost all hours of the day. Pictures like this, while cute, simply don't stand out from the crowd. It's just a little too plain.

To overcome this issue, all we have to do is change the height from which we take our photos. If you're interested in taking your cat photos to the next level, you're going to have to become well acquainted with the floor: kneeling, sitting, and even completely sprawled, belly down, on the ground. You will want to almost always take photos at an equal or lower height than your feline subject's vantage point, so keep that in mind when envisioning the backdrop to the picture.

Getting down on the same level as your cat will unlock an entirely new avenue of photography. You're now "seeing" the world through their eyes and are able to capture a fresh, unique experience for the audience. So, from now on, train yourself to always take photos at the equivalent or lower height of your subjects. Learn to love the ground.

Cute cat, but not an extraordinary shot. Get low!

ONWARD AND UPWARD

Great! Now that we've learned a bit about cat behavior, how best to approach our shoots, and tips on getting them to participate, it's time to learn some basic principles of photography. The following chapter will ensure that you don't leave the book without a fundamental understanding of what makes a good photo stand out, and how we can apply those techniques to our own shots to substantially raise the bar.

Chapter 2

Photography 101

I need to admit something to you guys. I'm not actually classically trained in photography! I ended up accruing the bulk of my expertise over the years by merely playing with a camera and trying various settings. I shot things intuitively, crafting my style to what I thought looked good and by emulating what I felt was successful in others' photos. It wasn't until years later that I learned more about the key principles of photography.

Fortunately for me, I discovered that I was already applying many of them unconsciously. In the upcoming pages, I won't be teaching from a podium and waxing on about nebulous concepts like shape and form. I didn't learn that way, so I'm not going to explain that way, either. I sincerely hope my approach to photography comes from a very relatable, unpretentious level that everyone can understand and draw from.

Some fundamental principles underlie why some photos are more visually appealing than others. Whether intentional or not, awesome photos reflect a mastery of a few, if not all, of these characteristics. By becoming aware of these foundations of photography, we can try to incorporate these concepts into our photos and improve our own shots. There's a lot to take in with this chapter, and you'll need to revisit these concepts as you develop and hone your own individual technique.

For this chapter, I have spotlighted what I feel are the most defining, game-changing principles in photography. These are Light (page 39), Color (page 57), and Composition (page 62). Under each section are a number of other interrelated concepts that elucidate further, or expand upon, the primary principle. There are many schools of thought in photography, but I think everyone can agree that having a firm grasp of the central ideas of light, color, and composition make the real difference when it comes to improving your camerawork.

LIGHT

Exposure

There's a good reason that light is the first section of this chapter. Proper lighting is one of the most complex, variable, frustrating, and essential components to a good photo, especially when you're photographing cats. The amount of light in your photos determines whether your cat looks like a shadowy figure from the netherworld or the clear and discernable angel you expect to show up in your shots.

A basic understanding of light—and how to best use it—is the foundation on which we will build the rest of our skills. If we get the lighting right, nearly every other photographic concept can fall into place more naturally, and we can go ahead and skip the rest of the book. This might sound ideal, but perfecting lighting in the real world without consistent studio lights, plain rooms, and even-toned backdrops is difficult. So, I'm sorry! You're going to be stuck with me for a little while longer.

In this section, I'll sometimes be referring to illumination in terms of exposure. Exposure refers to the amount of light within a scene or photo. Keep in mind that an individual photo can have multiple areas with different exposure levels, especially when you're dealing with natural light and its subsequent shadows. As I just mentioned, ensuring that a picture is exposed correctly will allow all the other variables in the photo to harmonize more smoothly.

When a photo isn't well exposed, you might find that many of the colors don't shine, the motion is blurred, and it's harder to make out much detail, especially with black cats! With proper exposure, a photo's

colors will be more accurate, the motion will be stationary, and the focus will be crisp. If you think about a camera, virtually all the knobs, buttons, and settings are there to modulate and control the amount of light that passes through. So, yes, understanding light is very, very important!

Outdoor shots will often require a bit more finetuning of settings.

To kick things off, let's talk about exposure and how it relates to photos in the real world. We can think of exposure in broad terms as how much light is present in the picture and how visible the image appears as a whole. The best way to illustrate different levels of exposure is to show the disparity between a photo that is underexposed (too dark) and a photo that is overexposed (too bright).

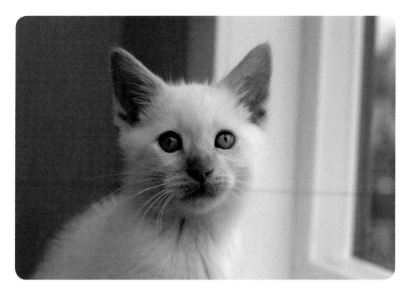

Underexposed shots lack all the finer detail
and rich color you'd hope for.

This shot is dark, shadowy, and the details are hard to make out. Unless you're shooting at night, in a dimly lit room, or have done so intentionally, there's no reason for your photos to be underexposed. This has a lot to do with user error, as an underexposed shot is the result of incorrect settings. If you find that you have underexposed a photo with a professional camera, the settings you applied just weren't right for the scene. This usually happens when your shutter speed is too fast, or you were attempting to get too much in focus.

When it comes to underexposed shots on smartphones, most often the room was too dark, the exposure area was incorrectly set, or the subject was eclipsing your primary light source. I'll talk a lot more about compensating for inadequate lighting as we get deeper into the book because it's the main contributor to bad photos. If you look back at the underexposed photo, there is a great deal of detail lost in the shadows. This can be difficult to fix with editing tools, and even if we're able to, we might find that the recovered detail becomes too grainy and makes the photo unusable anyway.

On the opposite end, we can overexpose a photo. This happens when the picture has individual elements that are too bright (sun, light bulb, etc.), or when the photo in its entirety was taken with incorrect settings. In the case of settings, it's virtually the opposite of what would underexpose a shot. For professional cameras, this means you shot with too slow of a shutter speed, too wide of an aperture, or too high of an ISO. With phones, it's likely that you chose an extremely bright spot in the frame to use as the overall exposure point.

An overexposed photo looks like this:

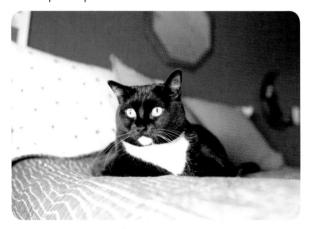

Overexposed.

Overexposure remedied in editing software.

Just as with shadows, depending on how you shoot, the overexposed areas can potentially be recovered with editing tools. However, there are hard limits to how much you can recover in postproduction, based on the format used and the intensity of the brightness. Some spots are irrecoverable, and the detail is completely lost, no matter how much you try to edit it. The areas will look like this:

Yikes! There's no saving this one.

When you're shooting with a phone, most smartphones will automatically attempt to balance the exposure levels in a given scene as soon as you ready your phone to take a picture. This doesn't always work in our favor, as significantly differing exposure levels (i.e., the sun coming through the window or a bright light in the background) will force the phone to pick one spot to use as its anchor point for exposure.

Fortunately, you can choose where to set your phone's exposure anchor point. If there's something in the scene that is overly bright or dark, you can manually change what your phone uses to calculate a

better exposure specifically for your subject. More about this soon in the phone chapter! Most dedicated cameras have an exposure meter built into the viewfinder or screen. The exposure meter gives you an average of the frame's exposure, and, when balanced with settings, gives you the best opportunity to have the frame adequately lit. It's not always 100 percent accurate, but it's a very simple starting point from which you can fine-tune.

As I mentioned earlier, you can also shoot photos that don't tend to be on just one side of the spectrum, but still have strong elements of light and dark. Here's a picture that illustrates this point:

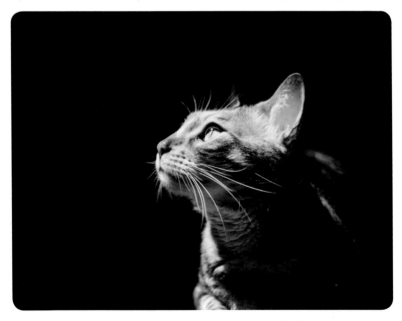

Haroun looking like he's about to drop the hottest R&B album of the year.

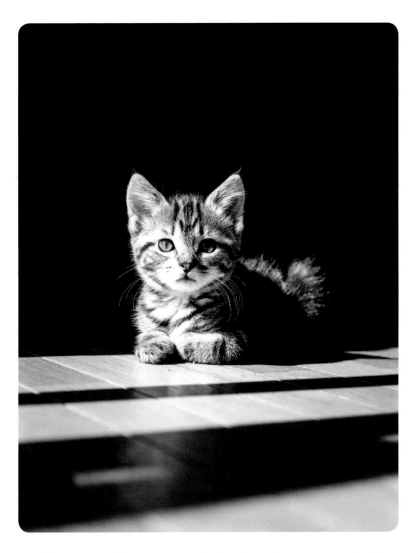

You can see that some areas in the photo above are very shadowy and near-black without detail. There are also sections that are perfectly illuminated. Even though this photo has vastly differing levels of exposure, because the subject of interest is visible and detailed, this would be considered a properly exposed shot.

Let There Be Light

Some of the most beautiful lighting you'll be able to attain comes from completely natural sunlight. For phones especially, this is often your best opportunity to get true-to-color, well-illuminated photos without using some form of external lighting. The sun is going to be a surprisingly reliable light source for helping us to take pictures.

Even when I'm using a flash in my shots, I prefer to shoot during the daytime with indirect sunlight pouring through the windows. This gives my camera faster autofocus and it gives me a better opportunity to capture what I'm aiming at accurately. It's the cheapest form of light (woo, nature) and can offer the most flattering, true coloration for your cats. It's also one of the best options for those of us who have black cats.

Natural light is best utilized when it illuminates the subject indirectly, or from the side. If your angle of approach has the sun beating down directly on your subject's face, it'll be harder to balance the rest of the shot. Similarly, if your subject is eclipsing or obscuring any part of the primary light source, the exposure levels will be all over the place. This is most notable if you're shooting at a cat looking out or sunbathing in a window. I'm betting many of you have experienced this scenario before, and the resulting shot can be pretty rough. So here's how we fix it.

Let's together imagine a typical stand-alone house. We have a couple of rooms, each with a few windows facing out in the cardinal directions. It's 11 a.m. on a clear day. The sun is overhead at a slight angle. If we recall second-grade science, the sun rises in the East and sets in the West, and, for the sake of simplicity, will reach its highest point at noon.

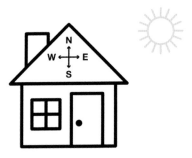

Here's our house. Cute, isn't it? Let's say that we have a cat sitting in the windowsill in the room on the east side, basking in the sun, enjoying herself. There's plenty of light shimmering down on her, and we feel as though it'll be easy to get some perfectly illuminated shots. We point our device at her while she's in the window and snap the shot. Here's what happens:

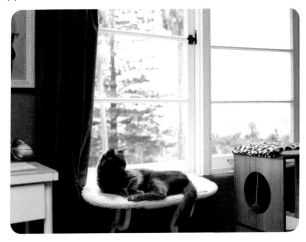

Wait, what? I thought we were supposed to be taking photos in bright light! This is bogus! You're right, it is bogus. Your device is doing its best to balance the varying levels of exposure, but only knows how to pick one. You can properly expose your cat, leading to extreme highlights coming from the window. Or you can properly expose the

outdoors, rendering your cat as a shadowy blob. The easiest thing to do in this instance is to change our angle of approach so that we're not shooting directly into the window and light source, but from the side. A good rule of thumb is never to shoot into a subject that is eclipsing your main light source.

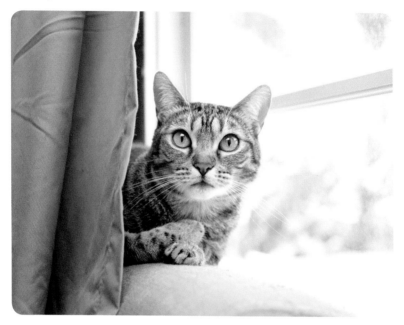

Peek-a-boo!

This will allow for an even exposure throughout the scene, and you won't have to decide which area to use as the anchor point for proper exposure. Another optimal scenario, given the same setting, is if Fluffy chooses to be in a different part of the house. She hopped down from the windowsill and is currently stretching out in the middle of the floor of the eastmost room. There's some light pouring in from the east-facing window. We could take this shot a million different ways, but how we position ourselves relative to the light source will make all the difference. As long as we shoot so that the sunlight is not being blocked by our subject or ourselves, we can really harness the power of the sun!

With a reasonable amount of natural light, you'll also find that your photos are no longer as susceptible to motion blur. As a result, the overall clarity of your shots will improve, and you'll be able to try more ambitious shots or achieve better results. Take a look at this photo.

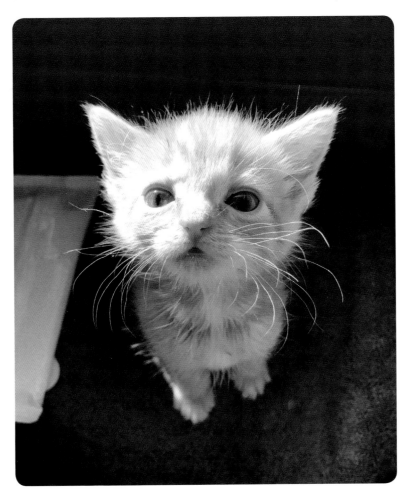

This photo was taken several years ago on an old smartphone. Look at the quality! It's impressive, right? A bright, well-lit shot like this is more than sufficient to print out and hang in your home. I owe it all to the big guy upstairs—the sun.

The best way to get naturally lit photos is to understand the sun's rotation relative to your house. It can be difficult if you're in an apartment and sun only shines through one window, in one room, at one time of the day. I've been there! I loved my old apartment in Philadelphia, but it had incredibly poor natural light. It was great for when I wanted to be a hermit, but absolutely terrible for my career as a photographer.

If I wanted a photo featuring direct sunlight, I'd have to be ready with my camera at 7 a.m. I had roughly an hour before the sun tucked itself behind my neighbors' rooftops for the rest of the day. Sometimes that's just how it is, so it will be essential to learn the sun's pattern at your place so that you can make the most of it. The sun has a slightly different color temperature at different times of the day; for instance, when the sun is setting, you might get more yellowish hues in your shot. If the photo comes out too warm, we can fix that. I'll be covering correcting temperature soon.

If you don't have great access to natural light, that's fine. You can totally work with what you have. But before you decide just to use the flash on your device, I would like to firmly discourage you from doing so. Onboard flashes, both the flip-up ones on your professional camera and the ones attached to your phone, are absolute garbage when taking cat photos. They ought to be avoided at all costs. You'll see why later. There are a bunch of substitutes and simple workarounds to the phone's flash that far outperform what's built into your smartphone. Dedicated professional cameras have more options, so while natural light is preferable, it's not nearly as much of a priority. I'll go over what we should use to supplement a frame's exposure for phones and professional cameras in their respective chapters.

Contrast

The most common form of contrast in photography is known as tonal contrast. Tonal contrast relates to the difference in luminance between the discrete components of an image. Like many other things in photography, contrast exists on a scale. This scale ranges from pure black to pure white, and the overall intensity of the photo's contrast is heightened when elements within the picture fall closer to the edges of the scale. This is much more noticeable in strictly black and white photography, but it applies to color photos, too.

Editing contrast is very straightforward, so it isn't something you have to think about too much while you're shooting. The way contrast manipulation works is that as you increase contrast, the blacks in the frame get blacker, and the whites get whiter. This can be used to make certain parts of images "pop" for the audience. As contrast decreases, the differences between blacks and whites get more muddled. Your image will become a bit grayer and less defined.

The following are examples of contrast before any editing is done. Here's an example of a low-contrast photo; the whites and blacks are muted or nonexistent. It's full of middle and low tones, and very few elements that are pure black or white.

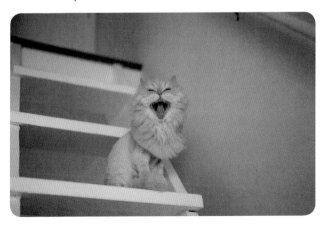

And now here's a photo with very clear blacks and whites:

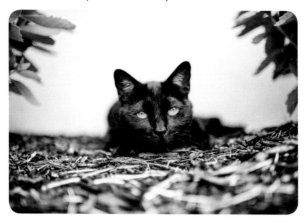

When we get to the editing section, I'll explain how best to modify the contrast to make the critical elements of the image stand out, even if the photo had naturally low contrast at the time it was taken.

There's an alternate definition of contrast that is much more of an artistic interpretation. Let me push up my glasses and adjust my bow tie. Okay, we're good. In this sense, contrast relates to the aesthetic difference between objects, or elements, of a frame. When you have two drastically different textures, themes, or objects next to each other, this is called juxtaposition. So when you're taking your shots, you can force the audience's attention to one notable area by virtue of its relationship to the other parts within the frame. **Here's a sample shot.** · · · · · · · · · · · · · · ·

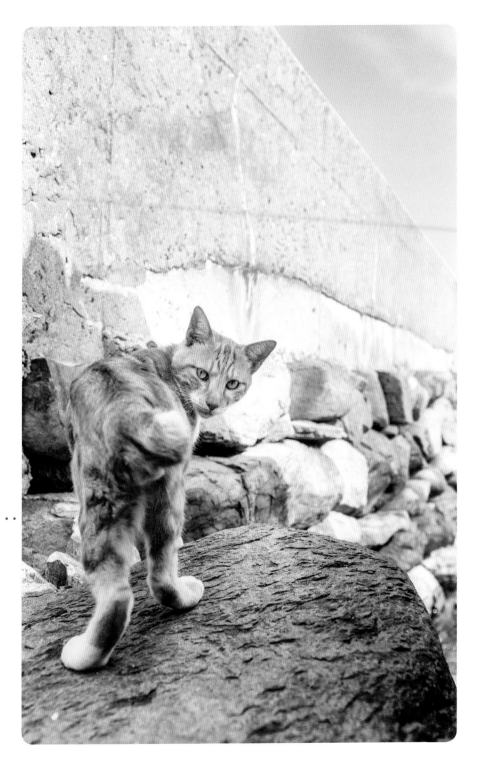

Dynamic Range

This is a fancy term for the range of brightness to darkness, or highlights to shadows, in a given frame. A photo with a very high dynamic range will be one with a significant range between the brightest part of the image and the darkest part. I suggest that when you take photos, they possess a high dynamic range. It'll help to create a fuller, more vibrant picture.

When shooting, we're almost always going to want to expose for the highlights. This means that if we have to sacrifice information or detail in the photo, we'll want to lose it in the shadows. It makes much more sense visually if a missing detail lies in the shadows, much as it would appear to the naked eye. Additionally, having a blown-out element in the photo sticks out like a sore thumb, whereas a darker shadow wouldn't. You might find that there is lost detail that we could have captured had we properly exposed the shot. **Take this photo of a cat outdoors, for example.** ·

No amount of editing will be able to recover the information in these highlights. We would typically be able to see much more detail with the naked eye; potentially clouds and birds, for instance. So, if the light we're working with is heavy on one side of the spectrum (i.e., bright sky), try to expose just enough to capture the highlights with detail. You might hear this called "exposing for the highlights." If need be, we can always bring out more details in the shadows with editing. It can be more difficult, or even impossible, to adjust for the overexposed spots.

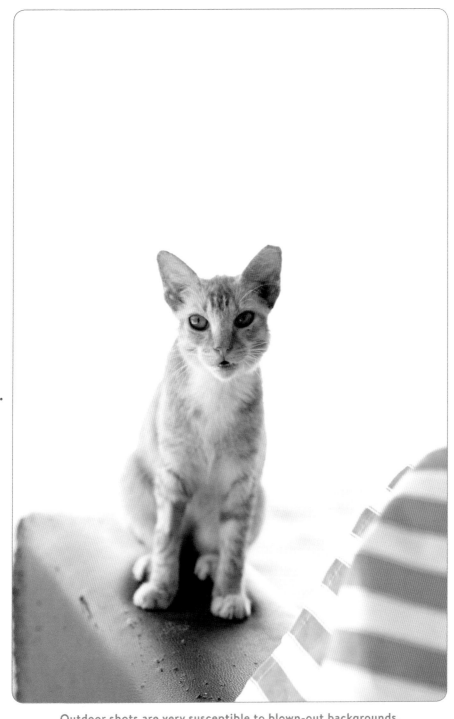

Outdoor shots are very susceptible to blown-out backgrounds.

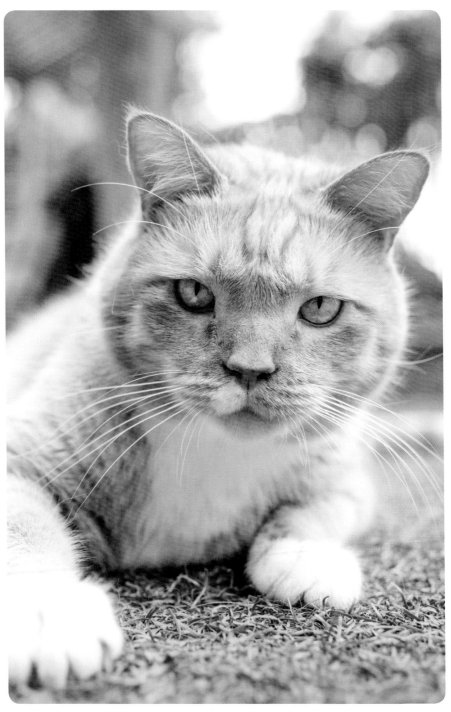

When white balanced, the whites won't be tinted by other colors in the scene.

COLOR

Believe it or not, one of the most important colors in photography is *white*. This might seem counterintuitive in a section all about color, but white is a bedrock on which all other colors can rest comfortably. White is what is known as achromatic, meaning it lacks hues and has the unique ability to reflect all visible colors on the spectrum without making them more vivid. If you think about professional photo setups, the reflectors on stands, softboxes on lights, and even backdrops are all white. This is not a coincidence! Utilizing a true white in your photography will allow all the other colors in the image to radiate at their full (and natural) potential.

Other achromatic colors are black and gray, but these colors are more light-absorbent and thus rarely used to reflect light. Considering that the majority of scenarios we will encounter on our shoots are not going to be set in entirely white rooms with blank backdrops, professional light setups, and assistants holding reflectors, we will need to use some additional tools or setup time to ensure that we calibrate the scene properly, whether in real time or while editing in postproduction.

White Balance

When I edit other people's photos, 90 percent of the issues are fixed by correcting for exposure and white balance. We've already covered exposure, so let's work on that other 45 percent. This one will invariably take a bit more finesse. Fixing the white balance is a slightly more imprecise process, because it's not quite as simple as increasing the brightness of a shot until you can make out the details. White balance is all about ensuring that the colors complement each other and work together in the photo to give you the closest approximation to the actual colors in real life.

When you go to the store and buy a light bulb, there are numerical indicators on the box reflecting the wattage of the bulb, as well as its "color temperature." The color temperature will be notated by something like this: 3000K—meaning that the color temperature of the bulb is 3000 Kelvin. If it's nighttime where you are, and you look around your house right now, you'll likely see that the majority of the bulbs are giving off a soft, warm light. These yellowish incandescent bulbs are standard in living rooms, bedrooms, and most areas of your house.

Softer light is easier on the eyes and contributes to a cozy, homey feel. Its temperature is similar to that of a setting sun, preparing us to end our day and go to sleep. In businesses, office settings, hospitals, and the like, you'll notice that the colors emanating from the lights are discernibly different. The lights will be much "colder" or bluer. To me, this colder light has a much more sterile, "Don't you dare take a nap under your desk at work . . . again" feel. This temperature is much closer to the sun high in the sky, suggesting that it's still time to be alert. Everywhere you go, and with every photo you take, there will be a color temperature to the scene dictated by the light.

The primary color temperature scale ranges from icy blue to deep yellow. If you're in a house lit entirely with warm, soft lights, the

subsequent photos you take will come out with a yellow tinge. Much more yellow, in fact, than they would be if taken in daylight or illuminated with a flash.

Remember how I said that standard lights around the home are listed at around 3000K? Well, unobscured sunlight and flashes share a very similar color temperature with one another, right around 5000 to 5500K. These temperatures are the range in which you'll get the most authentic, natural colors out of your photos because they will have the best natural white balance. As I mentioned earlier, true white is the best way to get the most natural reflection of light and subsequent colors in a scene.

Since we don't have the luxury of always shooting with sunlight as our primary light source, we can do a few things to counterbalance the temperature.

1. We can modify our device to compensate and correct for the temperature in the room. Most smartphones don't have this capability, but professional cameras do.

2. We can rely on flashes or fill lights to override the lights in our home.

3. We can change the temperature of the photo with editing tools after the shot has been taken.

For the most part, #3 is my preferred method. This allows you to shoot with the same white-balance settings on your camera at all times and edit the photo afterward. It's a pretty easy (and quick) fix, once you learn what to look for when you're correcting white balance. Even the free editing software included in social media programs give you a sliding scale to fix the temperature.

Additionally, there may be other factors that change the tint or hue of the photo, which aren't governed by the traditional temperature scale. Tint is different from temperature in that it ranges from green to magenta. You'll find that this is used less, but it can still have a major impact when it comes to correcting the colors.

Below (top) is an unedited photo taken next to a lamp equipped with a standard indoor light bulb. It's yellow, and that yellow bleeds into and affects all of the other colors in the photo. At bottom is the same photo, but white-balanced.

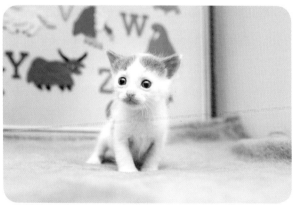

When white balanced, the whites won't be tinted by other colors in the scene.

You'll notice a vast difference in these shots! All we did was balance the tones to make them more neutral and true to life. If the photos you take appear too warm, make them cooler. If they're too blue, increase the yellow. It's a really simple way to make your shots look cleaner and more professional. As for other colors: Every color has its own scale when it comes to the hue, luminance, and saturation. As long as the white balance is close to correct, you won't have to worry about these factors if you're going for a natural look.

Saturation:
When Keepin' It Real Goes Wrong

There's an abundance of oversaturated cat photos on the net. When you're posting and fiddling with editing tools, you might be tempted to bump that saturation up to 100 (especially on the cat's eyes), but I implore you to resist this impulse. This. Looks. Terrible. What we're after is a genuine, authentic photo that mimics real life. It's totally okay to enhance some features and slightly bump up saturation to make colors pop, but don't go overboard. And be very liberal with filters! Just as you don't want to scroll through heavily overedited, airbrushed photos of people, you don't want to add to that pile of inauthenticity with your cats. When we get to the editing chapter, I'll be sure to give you a rundown of just how much saturation you should add to your shots.

COMPOSITION

Number 3! This is a big one. In this section, I'll be lumping in a few related concepts, because I feel like they are all equally important and interconnected. Check out these two photos. Which do you like better?

Framed much more intentionally.

If you're like me, you're probably going to go with the one on the bottom. It's well centered on all its axes, the focal point is in the middle of the frame, it follows some of the rule of thirds, and the visual weight is equalized. Succinctly, it's a well-composed shot. You might not know the precise definition of all the terms I just threw out, but the cool thing is that you were able to make your decision based on aesthetic values and intuition, not textbook terms. Now we'll talk about why that is so, because it's no coincidence that you gravitated toward the photo on the bottom.

Composition is just a fancy word for how all the elements of a picture are arranged within the frame. You will likely notice when a photo is well composed, but might not necessarily be able to pinpoint why. More importantly, perhaps, you can definitely tell when a picture is *not* well composed. Good composition appears to be effortless, but when it's done wrong, it is painfully obvious. There are countless ways to frame your shot. However, there's no absolute right or wrong way to compose a photo. It's mostly subjective, but you can follow certain guidelines, which will work to seamlessly enhance the shot for the audience.

Grid

A popular concept in photography is known as the rule of thirds. The rule of thirds suggests that you should visually separate your image into three columns, divided by three rows. This leaves you with nine boxes that comprise the picture. Now, according to the rule of thirds, focal points, or areas of interest, ought to be at locations of an intersection. It also recommends staying away from centering your subject in the frame. I'm not a huge proponent of this suggestion, as I don't think it lends itself superbly well to photographing animals, especially when considering the predominantly square format of social media

When you're given a limited amount of space to display your photo online, it doesn't serve you or the audience to fill the majority of the frame with negative, or unused, space. Negative space is an incredible tool to utilize down the road, but I really don't want you guys to get bogged down trying to get overly fancy with your shots so early on. Just as an example, so you can see what I'm talking about, at the top of page 65 is what a shot employing the rule of thirds looks like.

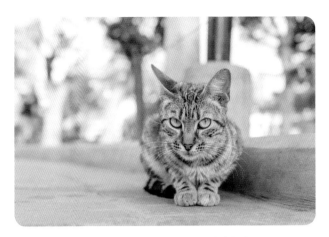

Photo utilizing the rule of thirds.

I'm not saying that it doesn't look good, but we should be careful not to rely heavily on negative space unless the extra quadrant provides additional context or helps tell the story of the image. To make the subject much more visible, we can fill the frame with the cat.

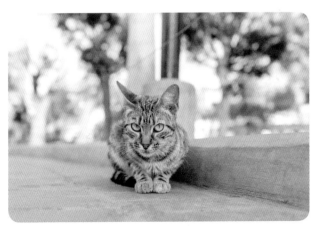

Not relying on thirds, but using the grid lines to center the cat's placement.

The shot above has more conventional, square framing. Even though we're not going to be relying heavily on the rule of thirds methodology, we can still borrow the nine-box grid.

This grid can often be found on viewfinders of your device, as well as within editing and social media apps. I use it to help guide the overall balance, or weight, of the photo.

Balance

There's a lot that could be tucked into this little concept, but, for our purposes, we're going to think about balance in terms of an image's distribution of its visual weight. Very broadly speaking, when I look at a shot, I tend to imagine the individual parts of the overall composition as having a corresponding weight. If there's something in the foreground, it has more weight than something in the background. A larger object will have more weight than a smaller object.

In most scenarios, the more space something takes up in the frame, the more weight it has attached to it. The goal, then, is twofold. Either we want to take a shot that distributes the weight evenly across the entire photo or we can choose to have equal parts of weight and absence. The absence of something in a frame, or the area without a subject, is what I referred to earlier as "negative space."

For instance, here's a photo that is not equally distributed and heavily weighted on one side:

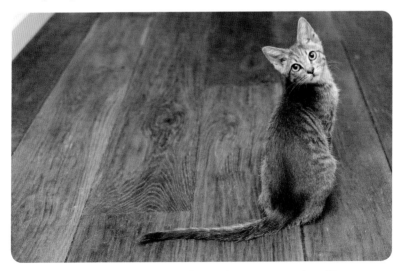

A considerable amount of negative space can be offset by the subject's placement.

If we were to cut this image diagonally, we could see that the cat is taking up almost a perfect half of the bottom right. We have a nearly equal amount of negative and positive space. I don't often go for shots like this, but they can be compelling because of their distinctive composition.

What I usually aim for is to have a much more equal distribution of elements within the photo, with a similar amount of positive and negative space. Ideally, I do my best to get the cat's main features in the center of the frame and their bodies and subsequent negative space around them take up the rest in equal proportions. Since we're starting out as burgeoning cat photographers, I recommend keeping your subject, or whatever feature or object you're emphasizing, in the center of the frame as much as possible.

On most devices, there's a little colored box in the middle of the screen. This is the area where your equipment will focus by default, assuming that you haven't changed something in your focus settings. This might seem like too much handholding, but we're going to walk through how to properly compose a scene step-by-step.

1. Pull out your device. While holding it and looking into the viewfinder or screen, guide the device's focus box to where the cat is, and aim at their face.

2. With their face still being the center point, move toward or away from them until the rest of their body fills the frame.

3. Now, center their entire body in the grid of your viewfinder or screen. Do your best to keep an equal distance from their bodies and the negative space or surroundings on all sides.

4. When you think there is roughly equal space on all four sides of them (up, down, left, right), snap the photo.

You should get something like this:

It should go without saying, but it is much easier to reposition your device than it is to reposition your cat. Try to follow your cat around for a minute or two like this without taking any photos, just using the focus box as the anchor point and keeping them in the center of the frame. If they're asleep or stationary, this should be a relatively easy task.

The goal of practicing continued focus on the cat is for you to become more inclined to place them as the centerpiece of the shot. As time goes on, feel free to experiment with weighting the shot with the cat in different quadrants or omitting parts of their body if you've zoomed in super close. You can get some really lovely shots by balancing a photo in unusual ways!

Just the Cats, Ma'am

Traditionally, I like to have the cat taking up the majority of the photo and equal amounts of negative space below, above, and on either side. Unless I'm going for an extreme close-up, I do my best to have the entire cat in the shot. Accidentally cutting off a part of their body in the photo can look odd, unless you're shooting a specific feature or region. Having a portion of the picture cut off tends to happen a lot with tails and outstretched legs. It's not the end of the world if you don't capture the tail in its entirety, but it's worth trying to get every part of the cat in the frame as a primary goal.

Similarly, do your best not to have any stray lines from objects, furniture, or pictures on the wall. It tends to make the photo look incomplete. If there's less than 5 percent of a picture frame on the wall, a random object, or a piece of furniture showing, try to crop the photo in to remove it from the shot. Here's an example of a cluttered shot rescued by cropping:

Cropping in tight removes the stray lines.

We want the focus to be on the cats! It can be visually distracting to have bits and pieces of an incomplete object in the shot. Also, unless the background is in some way integral to telling the story of the photo, we might as well crop the shot in and give the cat our undivided attention.

Here's an example of the background providing more context. While I could have cropped in on the two cats in the foreground, leaving the other objects and the house in the background helps tell the story of the image.

This photo is from a cat island in Japan. I kept the picture uncropped because my goal was to enhance the shot with background cues. You can make out the difference in architecture and there is some Japanese-style script on the sign. I felt as though these elements added flavor to the image. What I want you to keep in mind when you're taking photos, or reviewing those you have taken, is whether the background tells a story. Does it offer greater insight, convey an emotion, or enrich the photo in a meaningful way? If not, scrap it. Crop in tighter, distribute the photo's visual weight, and give the cat the full-on attention she deserves.

Perspective

This is something we discussed earlier in the previous chapter when we talked about "assuming the position." Perspective is an incredibly vital component to achieving awesome photos, but how it relates to composition is a little bit more complex to explain. Whenever you're setting up a scene, it's important to consider the angles of approach and how they will look in the ensuing capture. If we want straight lines in our shots (think floorboards, frames, tables, etc.), it's essential to keep in mind the three dimensions in which you're working. The three axes are x, y, and z.

If you recall from seventh-grade algebra, the x-axis is the horizontal one, the y-axis is the vertical one, and the z-axis is the one reflecting depth. As we take photos, we'll want to try to keep our devices appropriately placed in space so that they don't compromise the integrity of the axes. If we take photos at extreme angles, they will be much more challenging to compose into coherent shots.

If you're under the impression that this is just another thing that can be fixed in postproduction, you're only half right. When we're cropping and rotating to get straight lines, we might find that we run out of image space to appropriately "right" the photo. Another perspective fix comes from rotating our images in three dimensions, something that's available in a few editing programs. This can help fix the compositional angles in our photo, but at the cost of warping certain aspects of it. It's definitely something to use sparingly.

Formatting

The majority of photos we take with phones and cameras appear as a rectangle, either in a horizontal or vertical format. This might seem weird, considering that all the lenses we use are entirely circular. This is due to the way cameras work. Behind the lens lies a rectangular sensor that captures the light, and the shape of the photo is dictated by the shape of the camera's sensor. Square photos have become very popular as a result of social media, and now a lot of phones have the option to shoot as a square. While shooting in a square enables you to skip the step where you adjust and crop it, we really ought not to deviate from the rectangle.

Shooting as a square significantly limits the amount of visible space captured in the frame. A rectangular photo offers a multitude of options when it comes to preparing the final version. When you shoot as a rectangle, you retain the ability to adjust the angles, position the elements, and crop out unnecessary extras in a way that square formatting simply doesn't offer. Opting to shoot as a square inherently limits you drastically. So, if you're really keen to produce a square image, shoot it as a rectangle, and frame and crop it later on.

Squeaky Clean

No one wants to see your dirty laundry in the background, all right? I mean, maybe some people do, but let's not give those weirdos what they want. A huge factor in a photo's overall composition is how clean it feels. Take a quick look at your surroundings before assuming the photo position. Is there anything in the area behind the cats that might be unsightly in a photo? A stack of papers, miscellaneous floor filth, or dirty

dishes can dramatically impact the overall quality of the picture. These things are considerably easier to clean beforehand rather than editing out later. I've kicked myself while trudging through an editing session for not taking the time to properly clean the surroundings before a shoot.

Unless you're determined to start a conversation about the medicine you have on your nightstand or the fantastic Korean horror DVD collection in your entertainment center, leave them out of the shot. People notice these things! Having fewer distracting elements in a photo goes a long way, especially if you're taking shots of adoptable animals. If you think about it, people are going to be much more inclined to adopt an animal if the background has plain and indistinct features. Prospective adopters will be able to envision an animal in their home more readily. You might think that this gives the environment a blander feel, but it will spotlight the main subject significantly. Much like the compositional tips I shared earlier, unless the background helps to tell the tale or provides more context for the image, think about cropping in.

Texture

I know what you're thinking: *Yikes, this is where he's going to use some pretentious photography terms and try to flex on us.* I promise I'm not! Texture relates to how the photo feels with your eyes. Imagine picking up a picture, looking at it briefly, and then scanning the surface by rubbing it with your eyes. This is a weird visual, but I hope it gets the point across. There will be areas that are pillowy soft and creamy, which are very friendly on the eyes. There will be spots that are more heavily detailed and crisp, which will require a lengthy glance to make out all the little features. You've probably seen photos that are all one or the other. These usually look really bad.

Here's something I see more often than I wish I did. I like to call it "angel baby." This is terrible! I'm not expecting you to do this, but if you have any inclination to, don't. What tends to look best lies within the contrast of texture; a bit of each, creamy and detailed, to complement each other and produce a balanced photo. I often like to have the background of a shot very soft and out of focus, while the main subject is highly detailed. If I'm having trouble getting a detailed photo of a cat's entire face, then I'll at least make sure that the eyes are in focus.

Focus

We touched on this a few pages ago, but let's again start with a simple setup for achieving a desired focus point, and then explore how altering the focus can create texture in your shots. Imagine that our cat is front and center in the frame with the primary focus point being locked on their face. The way I like to think of focus is that it's an imaginary box in space. The depth of the box, or the amount that we can get in focus, is dictated by our aperture. Aperture is the hole through which light passes to the camera's sensor. (If you flip ahead to page 120, I explain aperture in much greater detail.) The area on which we focus is critical to developing texture in the rest of the frame. Depending on how much we choose to place in focus (or how big we make the box), we can allow the cats to either stand out from their background or blend in.

In most cases, we're going to want the cat to be the prominent feature and pop from the background. The way we do this is by introducing depth into the shot, which draws attention to a specific area of the photo. This is most notably done by mechanically adjusting the depth of field on dedicated cameras, but newer technology in smartphones enables you to get the same effect to a comparable degree. I'll cover how to do this for both of the devices in their respective chapters coming up.

Composition is all about being attractive to the audience and creating a cohesive picture. Photos with a thoughtful balance of elements, centered shots featuring the cat, coupled with a clutter-free background will most certainly stand out and help to reach the status of an "awesome shot."

F/10 shot: Everything in focus

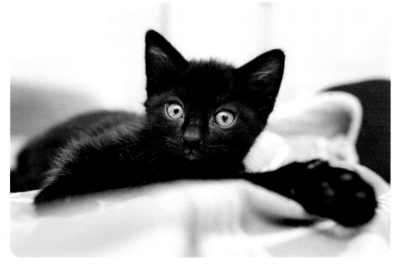

F/1.4 shot: Only cat face in focus

Chapter 3
Phone Photography

Advances in the quality of phone photography over the past decade have been monumental. Some photos taken with a smartphone are indistinguishable from those taken with an expensive, professional camera. Ten years ago, when I picked up photography and started shooting with a dedicated camera, my phone's capabilities amounted to little more than an electronic potato. I took photos with it, of course, but they were far from intelligible, let alone award-winning. Modern phones are considerably more powerful than that first dedicated camera I once used, the one that jump-started my career. That is to say, big, bulky professional cameras aren't everything!

Now while I'm happy to espouse the benefits and even advantages of smartphone photography, we can't get too hyped up about it. I'm going to have to briefly temper your expectations *juuust* a bit. Smartphones still fall behind in a few key areas in which dedicated cameras really excel. The most obvious caveats to phone photography are terrible flashes, fixed aperture, fewer settings, and lack of variable lenses.

You can, however, achieve some stunning shots worthy of posting to social media, framing in your home, or being used for intake cards at your local shelter using only your phone. What we're going to focus on primarily is playing to the smartphone's strengths and then doing our best to compensate for their limitations. But first, let's take a look at the anatomy of a smartphone, so we know what we're working with.

ANATOMY OF A SMARTPHONE

There are a range of smartphones out on the market, and they're each a little bit different. Fortunately, they share some notable commonalities in their structural makeup.

Lens

Smartphones all have a lens. Sometimes they have multiple lenses. What's popular on most models today is at least two lenses: one on the front, facing forward, and one on the back to take photos of others. Typically, the one on the front, used for selfies, is of inferior quality. You might notice that the contrast, clarity, resolution, and low-light capabilities are a bit more limited with the front-facing camera for obvious reasons. More likely than not, your subject (usually you) won't be much more than an arm's length away. The back lens tends to have a more advanced sensor (see below) or is made with higher-quality materials. Your lenses may be fabricated with glass or plastic, but most these days are glass.

Sensor

This is the other component that makes a significant impact on the photo's quality. The sensor is what takes the photons (light particles), gathered by the lens, and sends them to be processed by the camera's software. With each passing year, you may hear news stories about the newest phone's camera capabilities and the upgraded amount of megapixels, or MPs, they have. Megapixels correspond to how many photodetectors there are on the sensor. So if your camera has 12 MPs, it has 12 million microscopic photodetectors on the sensor. Each photodetector picks up light, which corresponds to a particular section of the photo. The more MPs your camera has, the more photodetectors it possesses, the more detail can be displayed in the finished result.

Those are the basic parts of the phone that we should be aware of. I'm going to skip the flash entirely because they're all terrible for animal photography and should only be used in extreme circumstances—like snapping photos of a raccoon posse raiding your neighbor's garbage bins.

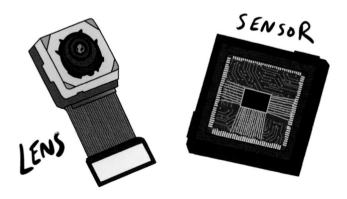

CAN'T SMUDGE THIS

Before we delve any deeper into using your smartphones, I'm going to give you a reliable, grade-A tip to improve your shots immediately. Clean your phone! Do the huffing, breath-y thing on the lens, fog it up, and wipe it clean. We might not realize it, but let me remind you: Our hands are absolutely disgusting. Some of you may have jobs working in perfectly sterile environments (yeah, right), but me, I get peed and pooped on by kittens at least once a day.

Even though I wash my hands all day long, filth and grime get passed along to my phone without me even realizing it. Throughout the day and multiple handlings of my phone later, it gets gross. When I pick up my phone and accidentally touch the lens area, this is where I run into problems. If you've ever been taking pictures and suddenly realize that the shots are a bit hazy, have some orbs in the background, or feature unusual light trails, don't worry. You're not being visited by a ghost, Linda. You're just greasy. Take two seconds and wipe your lens clean! I also totally recommend picking up lens wipes or cleaner specifically made for more expensive glass. This can be useful if your breath isn't cutting it.

I'm going to highlight the positive aspects of smartphones before we talk about the negatives. There are a lot of reasons that shooting with a phone just makes more sense for the average user. I think that, for some individuals and in a handful of specific cases, taking photos with your smartphone is actually more advantageous than using a dedicated camera.

CAPTURING
THE MOMENT

||

What's the best camera out there? The one you have with you. Phones are great. They're super accessible, very straightforward, small, and usually in your pocket or by your side most hours of the day. Honestly, it's the first thing I grab when a cute scenario is unfolding before my eyes. It's pretty uncommon to have a dedicated camera on hand, ready to capture a spontaneous moment. Invariably, when I experience a super cute event, worthy of going to grab my dedicated camera, whatever I had wanted to photograph has long since dissipated. One of the greatest strengths of smartphones is how ubiquitous they are.

This is one of my most liked and shared photos of all time. · · · · · · · · · · ·

While I'm happy to admit that this photo is super cute, I had to ask myself what made this shot so special. I have literally thousands of other images of kittens doing obscenely cute things, taken with expensive professional equipment. Why this one? Well, I think I figured it out. To put it succinctly, it looks real. Sometimes the ultra-high-definition quality of cameras does not always feel realistic. I believe this photo was so heavily liked because people could envision themselves in a car, stuck in traffic, whipping out their phone and snapping an authentic adorable moment.

Phone photography is immediately relatable. There is no pretense. You don't have time to stage this kind of shot. It's genuine, and the audience knows it. Having such a powerful device in your pocket to capture spontaneous moments is one of the greatest strengths of phone photography.

FULL AUTO

Using a smartphone's camera is relatively simple. You point at the subject, hold still for a moment, and press the capture button. You don't have to do any calculations on the fly about the levels of light or shutter speed. The phone does it on its own. When you open the camera application on your phone, it takes an initial reading of your environment, runs some algorithms, and determines the adequate settings for the scene all by itself. This cuts out a lot of the guesswork you might otherwise face if you're not familiar with camera settings.

Smartphones are so easy to use that anyone, including your technologically inept Luddite grandma, can take a reasonably clear, well-lit photo without thinking twice about it. This is nothing short of a miracle. Additionally, having a large screen showing you what the picture looks like in real time before you take it is an enormous benefit. You don't have to squint through a tiny viewfinder or look at a small LCD screen to see what you're doing. This is a really big advantage.

Coupled with the ease of taking and sharing your photos, you have almost unlimited storage on a phone. Especially if you upload your pictures into your phone's cloud service. Making folders and storing specific sets on your device is an absolute breeze. Once you learn how to do it, it will completely revolutionize the way you're able to keep your content organized and saved. Many phones also have a feature whereby you can *star* or *heart* photos as you're scrolling through your library. This will automatically place them in a favorites folder for easy access.

Here's a quick buzzkill reminder: For now, your phone's adaptive technology only goes so far. Most fully automatic settings (even on dedicated cameras) make crude predictions based on what the sensor is perceiving, and bases those predictions on a stationary subject. This is especially noticeable when you're trying to take photos of a moving cat

at night. If the only light sources are lamps in your house, you'll find that when you snap photos, they're blurry. Low-light photography of moving objects is already challenging, but with smartphones, it's nearly impossible. I'll talk about workarounds and potential ways to fix this coming up, but this is a considerable limitation to make note of.

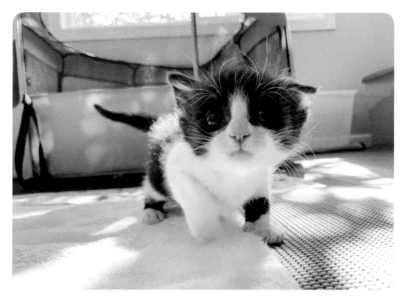

With ample light, you can catch a moving target relatively easily.

SNAP AND SHARE

With smartphones, you can instantly share your shots with thousands all around the globe, mere seconds after taking the photo. Of course, you can spend time processing or editing the picture on your phone, but it's not going to take nearly the amount of work (and time) that a photo from a traditional digital camera does. The workflow for a digital camera can involve several additional steps depending on the format you're using.

Usually when I'm on the job with a dedicated camera, none of the photos I have taken can be shared until many hours later. I have to upload the files onto my computer, import the images into an editing program, edit them, save them as a different kind of file, upload them to the cloud, and then download them onto my phone. It's time-consuming! Professional camera companies are definitely noticing this trend and are improving their technology so we can share the photos we take with these cameras more quickly, but there's still nothing faster than smartphone sharing.

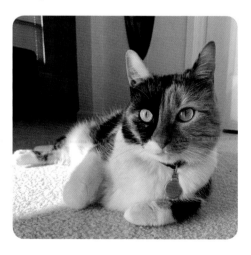

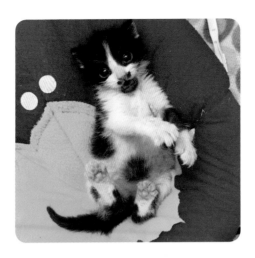

THE PRICE
IS RIGHT

This is where things can really start to become a bit more personal and subjective. What is expensive to me might seem like little to you, or vice versa, but, generally speaking, professional/dedicated camera equipment isn't cheap. Even at the beginner level, you're talking about spending upwards of a few hundred dollars for a starter kit. This can be a significant barrier to hobbyists or those who are simply photo-curious. Smartphones aren't cheap, either, but when you consider all the additional functionality they have, it becomes far less of an impulsive purchase. You can do way more with a smartphone than you can with a dedicated camera.

Now that we've run down the pros, it's time to talk about the caveats of phone photography. There are many, and here's where we have to start heavily compensating if we want our photos to be awesome in every and any circumstance.

LIGHT IT UP

Smartphones absolutely shine in lots of natural light. See what I did there? I'm not necessarily talking about a requirement for clear, sunny California afternoons (although those days are amazing), but we'll want to try to do most of our shooting during the daytime when the sun is still up. We talked about it earlier, but sunlight offers close-to-perfect white balance for our photos. Also, having an abundance of light will make it easier for our phones to take crisp shots. A well-lit scene allows our phone's autofocus system to be much more effective. The way the focus technology works is that it tries to find well-defined edges in a given section of the frame. If the scene is poorly lit, the edges of your subject—in this case the cat—will become muddled and indistinguishable from the background.

It's difficult for the software to figure out what's important to focus on and the result will often lead to blurry shots. This happens when your phone never finds a sharp point on which to focus. If you've ever taken photos in dim light, you know exactly what I'm talking about. The autofocus system will zoom in and out gradually but never find purchase. Our phones can't pick up edges very well, especially in shadows or low light. This is one of the reasons that taking photos of black cats is so challenging, especially with phone cameras.

Low-light shots will also make capturing movement much more difficult. In the next section I talk at length about all the different variables you'll find in professional cameras, one of which is shutter speed. Shutter speed controls how long light can go through the lens and onto the sensor. This is one of the greatest determining factors to capturing action. With our smartphones, we usually have little control over this, unless we use a third-party application.

If you're taking photos with your smartphone's built-in camera software, it adjusts the shutter speed for you based on the amount of light in the scene. In low light, your phone's shutter speed will automatically get to as slow as one-third of a second. This is way, way too sluggish to capture movement adequately. The best way to address both the focus issues and the shutter speed problems is to pour additional light onto the scene.

You might be tempted to hit that little lightning icon and utilize your phone's flash. Well, unless you really like taking photos of possessed felines, you're going to be disappointed with the results. Not only will the flash wash out the shot, but it will create a very unflattering glare in your cat's eyes. There is a special layer in there that helps cats see better at night, called the tapetum lucidum. This will reflect the light from your flash in a very harsh way.

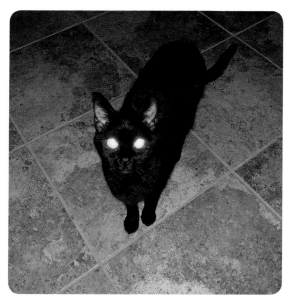

Bright light! Bright light!

EXTERNAL
LIGHTING
SOURCES

There are a bunch of cheap and effective ways to increase the light in your shots without using your phone's flash. I would highly recommend using a handful of products, the best of which is the simplest and most portable. It's a selfie ring-light.

Before you start cringing, hear me out. Buying one of these isn't going to turn you into a depressing Instagram butt-model influencer. For the price, it's one of the most powerful external lighting sources you can get. It doesn't need to be plugged in to work, it is small enough to be handheld at all times, and it can even clip on to your phone. Its intended purpose is just to clip over the top of your phone and light up your face while you're trying to sell bogus fitness tea to your followers. But we're going to make use of it in a way that these companies never anticipated—to take photos of our cats.

I would recommend holding the ring-light with your nondominant hand while you take the shot with your dominant hand. The clip-on feature is nice, but the light will end up being too abrasive if you're shooting up close. You'll get the best results by holding the ring-light and angling it just off to the side of the frame. You will want to gently cascade the light onto your subject and position it toward the face. It can really make a difference in your shots. Here's an example:

A simple ring-light turns a shadowed figure from this . . .

. . . to this

If you're looking for something a bit sturdier, there are many larger LED lights on the market for as little as $25. Most of these are square or rectangular and can sit upright or be used with a tripod. The one I have uses a rechargeable battery and can be set up off to the side of a scene to provide additional illumination. These lights are commonly referred to in the photo world as "fill lights."

Fill light is just what it sounds like. It is most often used to complement a scene by illuminating the shadows or other areas that the flash doesn't directly hit. In studio environments, you'll usually have at least one, if not two, fill lights on the subject at all times. I find its greatest use with cats is that it can brighten the scene before you use a flash, giving you the option of using a less powerful burst, and, most importantly, allowing your camera to focus directly on the subject.

In lower-light scenarios, or when you're shooting a totally black or white cat, it can be challenging to get the camera to focus on the cat's face. Cameras do their best to pick sharp edges in the frame, but if the scene is not well lit, it'll all be shadowy and without form. If you plop down an additional LED light near the subject, the shadows will be lessened, allowing you to focus much more quickly.

I can't recommend grabbing one of these strongly enough. If you've got money to spare, you can also purchase more professional ring-lights and LED setups. They can get to extremely bright levels and have the potential to light up a whole room. The downside is their price tag and portability.

Once we have the lighting down, we can use another technique to increase the chances that we'll get a clear action shot. This is what I call *spray and pray.*

SPRAY AND PRAY

When I'm taking photos, I never press the shutter/capture button only once. The likelihood that I actually captured precisely what I was attempting to in that millisecond is extraordinarily slim. Especially if the goal is to get a shot with a tongue out or another fast action. If you don't do this already, I suggest making burst photography a new habit. If you can imagine the last time you witnessed a public hearing, a press conference, or any event that garnered news coverage, your mind can quickly conjure the sounds of dozens of camera clicks going off in rapid succession. This is because we all play the odds game when taking photos. We're counting on one of the images in the series to come out well.

If you're anything like me, your camera roll probably looks like what you see on page 97. Lots of photos of cats, most of which are a little blurry. This is a very common problem for anyone who takes pictures of their animals, so don't worry. When I'm shooting with my phone, many of the photos I take are affected by motion blur. Cats don't typically stay still unless they're napping. When they're awake, cats have an agenda that doesn't often involve sitting around on a coffee table wearing a stupid hat for 20 minutes while you try to get a good, clear shot of them. We have to make the most of our brief photo opportunities with cats. Burst mode will help you cut down significantly on the clutter in your camera roll and actually get the split-second shot you were after.

On most modern phones, the way to take burst photos is simply to hold down the capture button. You'll be able to blast off up to 10 frames per second, which is really impressive, even compared to professional cameras. From here, we just revisit the photo library on our phone and scroll through the burst shots to find the best of the bunch. This is a much easier process than taking shots individually and hoping we captured what we wanted.

There's also a hidden bonus to using burst mode. A funny thing I like to do with bursts is to stitch them together using a third-party application.

You can create hilarious triptychs of your photos like this. · · · · · · · · · · · · ·

This would not be possible without burst photography! You can also make short gifs or videos with your burst photos to play on loop, While photos are an excellent way to convey your animal's personality, sometimes videos can do it better. Creating loops of your photos can provide greater insight into their behavior, especially if they're doing something ridiculous. And isn't that just about always?

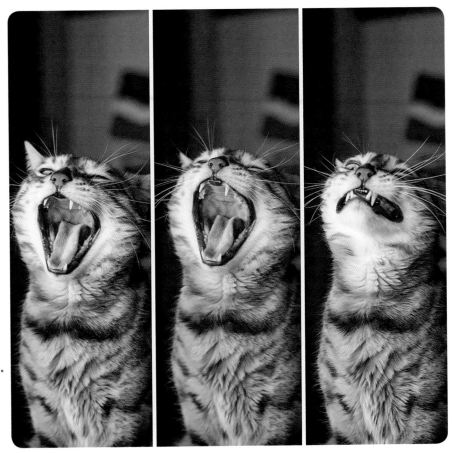

You're cute, even when you're not.

FOCUS UP

Some of you might already know this, but just in case you don't, you can change the focus point and exposure anchor of your shots just by tapping on the screen. If you're taking a photo and you find that it's way too bright in some areas, tap the brightest part of the screen. It will attempt to balance the exposure based on the area you selected. The same goes with focus. Wherever you tap on the screen, your phone will try to focus.

This can be extremely useful if you have multiple cats in a scene, or if there are other objects in the foreground. Believe it or not, our phones' ability to capture multiple cats in focus with ease is one of its biggest advantages. The vast majority of phones have a fixed aperture, and that aperture rating is usually really high! We're talking f/13+. This lets you really extend the focal depth to include more than just one cat, something that professional cameras have a harder time with.

By selecting the focus, you can have pinpoint control over what becomes the object or area of attention. Choosing the focus point can also open up the option to modify the exposure. When you tap a spot and see the camera refocus, you might notice a little sun icon with a slider. By moving the slider up and down, you can increase or decrease the exposure level of the shot on the fly.

PORTRAIT MODE

This is a relatively new feature on smartphones, but most are equipped with this option now. Believe it or not, it actually produces a pretty good simulacrum of genuine shallow depth-of-field photos that used to only be achievable with professional cameras. Portrait mode mimics photos where only a featured section of the frame is in focus, and the rest is slightly blurry and out of focus. This further isolates the subject from the background, and it looks really artsy and cool!

Unfortunately, there are a couple of noticeable issues that arise if we opt to use portrait mode to capture our cats. First and foremost, the fallibility of the software that's manipulating the photo; it's not a mechanical feature as in dedicated cameras. Just as our phones can be poor at picking up edges to catch focus, they can fail us here, too.

You will find that the software has a difficult time distinguishing between edges and the background. What happens is that some areas that are meant to be in focus become blurred out, and vice versa. This is especially noticeable when it comes to fur, and unless you're working with a Sphynx cat, your feline subject has plenty of it. If you don't scrutinize too carefully, you might be able to get some mileage out of the portrait mode feature. But, as of now, the software is still lacking in critical areas.

SELFIE MODE

Although the front-facing lens might be of slightly lower quality, there are some clear benefits to using the selfie cam. If you ever want to showcase a cat's interaction with you and also be in the frame, selfie mode is going to be your go-to mode. On top of that, having a real-time visual indicator of the photo's outcome is a considerable advantage if you're not able to be behind the camera.

You can also utilize the timer feature to snap a picture that would otherwise be impossible. The front-facing camera, along with the visible screen, allows you to properly compose or stage a shot while you're in it. This can be invaluable for capturing the precious dynamic between you and your cat. Often, what I'll do is put my phone in selfie mode and place it in the windowsill, with the screen facing toward me. The placement helps to get an appropriate amount of light from outside to

illuminate the shot. I'll set the timer to three or five seconds, click the capture button, and pick up my cat. I compose the rest of the shot in real time and then hold for the click. I wouldn't recommend anything more than a five-second timer, as you might find your subject getting restless. If you didn't nail the shot the first time, give your cat a break before trying again.

You can also opt for more accessories to help you take shots in selfie mode, if that's your thing. You can pair remote clickers with your phone, so that every time you press the button, your phone will take a shot. You might also want to invest in a small phone tripod if you antic- ipate using this feature a lot. There are a couple with twisty, bendy legs that can attach to any surface with relative ease, or stand straight up like a traditional tripod.

BLINGED OUT

If you're really married to the idea of capturing the best-quality photos with your phone and have a few extra bucks to spend, you can opt to buy some detachable lenses for the phone. These clip or slide onto your phone and will cover your existing lens. They can be used to do a few specific things, but they work by changing the focal length and mag- nification of your shots. The innate focal length of the typical phone's camera is anywhere from 20mm to 30mm. This grants a relatively large field of view, but if you wanted to be able to take extremely wide-angle shots, zoom in more without sacrificing quality, or even take macro shots, you will want to grab one of these lens adapters. Additional lenses vary considerably in price. I personally don't use any, but I've heard good things about them and think it's definitely a purchase worth considering.

HORIZONTAL OR VERTICAL?

This one is a bit contentious, especially when it comes to video footage. Before recent changes to social media platforms, I would have advocated for exclusively capturing in horizontal mode. But now there are many more options in the way you can share images. Aside from the popularity of square shots, you can also share photos with a more vertical layout, which actually allows for more of a photo to be seen than the square format.

You can also share purely horizontal pictures, but on platforms like Instagram the subsequent shot will be pretty hard to make out. In horizontal photos on small phone screens, the cats and their features are too hard to see. It's a formatting thing, so know where you will eventually want to post your photos. I typically shoot vertically with my phone; my partner shoots horizontally. It really comes down to preference. The only thing to keep in mind is if you're shooting video and plan on uploading it to video hosting sites, you'll want to make sure that you take it horizontally, due to their specific formatting.

HDR MODE

The benefits of HDR mode are massive and separate smartphone cameras from professional cameras in a big way. You know the situation in which there's an extremely bright feature to the frame, and it's hard to balance the exposure to capture both the darker subject and the bright light? There's something called HDR mode on smartphones that will totally revolutionize the way you take these shots.

Here's what HDR mode does: It takes three photos for each shutter click. The first photo exposes it for the highlights. The second is a more balanced, equal exposure. And the third exposes it for the lowlights. Then, the software pancakes the photos and picks the best possible exposure levels for each of the areas in the picture. This allows you to have a photo that is appropriately exposed for both the very bright light source and your darker subject.

Here's an example. ·

For our purposes this is nearly impossible to do with dedicated cameras, as manually modifying the settings in between shots and maintaining the exact scene typically requires a tripod and a perfectly still subject. Good luck with the latter!

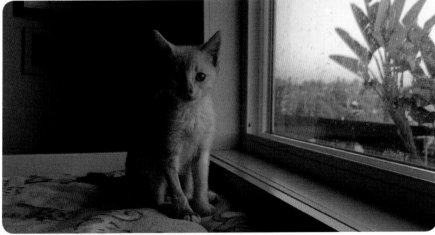

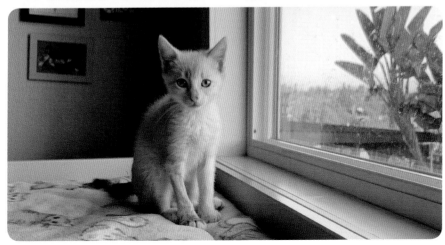

PLEASE DON'T . . .

I need to leave you with some last-minute don'ts. These are all based on things I've witnessed people doing and are terribly wrong. Sorry, Mom, but you're guilty as sin. First, unless your phone has multiple lenses on the back that have *optical* zoom, do not zoom in before taking the photo. There is a big difference between optical zoom and digital zoom. Optical zoom utilizes the mechanics of the lens itself, by either panning in or, in the case of phones, switching to a lens with a higher focal length and magnification. Digital zoom is using software to crop in on a scene. This reduces the quality of the image significantly, as you're seriously limiting the amount of megapixels being utilized. This means a big downgrade in resolution and a big reduction in quality. If you've ever wondered why your zoomed-in photos are super grainy, this is why.

Even though you may eventually want to zoom in on the photo before you post it, do it after you've taken it at full resolution. Similar to the section on composition, where I implore you not to shoot in squares, shooting while zoomed out gives you more options to change the photo in postproduction. If you've only shot while zoomed, you're naturally limited to what you captured and you won't be able to make any substantial changes in the composition of the photo.

Just as we don't want to limit our options by shooting while zoomed in or squared, please don't shoot photos with a filter on them. It might look artsy and cool at the time, but we can always apply and change filters afterward in postproduction. You essentially doom the photo to whatever you felt was cute at the moment. In the harsh, cold light of morning, you might second-guess your filter work. Well, guess what? Can't do anything about it now. So, do yourself a favor and leave your photos as untouched as possible so that you can mess with them later on.

Chapter 4
Dedicated Cameras

Phones are great for capturing the moment and serve as an excellent entry-level device for photography, but to get the most vivid, detailed shots of our cats, we're going to need to bring out the big boys. Professional, or dedicated, cameras, as I like to call them, require a more significant investment, but in turn give a much greater payoff. These cameras offer higher-resolution photos, a vast array of detachable lenses, and the ability to really express your creativity by way of finely tuned settings.

We have *a ton* to cover in this chapter and I want to make sure we are very comfortable with the basics so that we can properly use our cameras. So many individuals buy, or are gifted, dedicated cameras, and never commit the time to learning the ins and outs of them. Fortunately for you guys, this should be concise and informative.

There are a few different types of dedicated cameras, so figuring out which one best suits your needs is important. We have:

	Pros	Cons
Point and shoot / fixed lens	Cheap, small, portable, decent starter camera, easy to use	Lack of interchangeable lenses, less functionality, lower resolution
DSLR / digital single lens reflex	High resolution, interchangeable lenses, lots of settings/functionality	Bulky, heavy, can be very expensive
Mirrorless	High resolution, interchangeable lenses, smaller than DSLRs	Expensive, lower battery life, fewer lens options

I have tried and tested all kinds of cameras and personally use a DSLR camera. I find that it has the best balance between budget, functionality, and quality. As with any hobby, costs increase substantially as you get into higher-end equipment, but the improvements you see do not necessarily reflect the higher price tag. If you're put off by the high cost associated with dedicated cameras, I encourage you to check out secondhand cameras and lenses on aftermarket or auction websites. The barrier for entry to dedicated cameras doesn't need to be exorbitant. It's possible to snag some really incredible deals on used equipment and start shooting at higher quality on a budget.

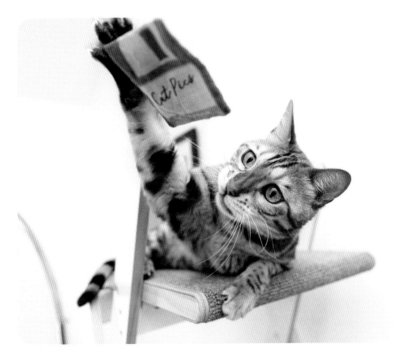

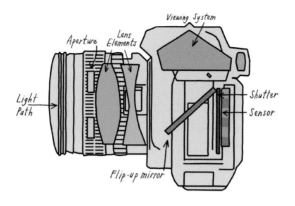

Viewing System

Aperture

Lens Elements

Light Path

Shutter

Sensor

Flip-up mirror

ANATOMY OF A CAMERA

Similar to the phone chapter, we're going to briefly cover the main components of a dedicated camera.

Body

This is the part of the camera that houses all the electronics and software necessary to turn photons into an image file. If you're using a DSLR, it also houses a shutter and a mirror. When you look into the viewfinder of a DSLR camera, you're looking at a mirrored image coming through the lens. If you peek inside the body, you can easily identify the mirror. Mirrorless cameras don't have this and are much lighter and more compact as a result. When you look into the viewfinder of a mirrorless camera, you're being shown what the sensor "sees" in real time.

Shutter

This is a mechanical piece within the body that moves to allow light from the lens onto the sensor. Depending on how fast you set your shutter speed, the shutter can remain open for several minutes at a time, or as quickly as 1/8000th of a second. The distinct "click" you hear when you take a photo is due to the shutter's adjustments.

Sensor

The sensor is an exquisite piece of hardware that determines the resolution and quality of your shots. It is a component inside the camera that is covered in millions of extremely small areas called photosites. There's a photosite for every pixel, so if your camera sports 10 megapixels, it means that there are 10 million photosites on the sensor. When a photo is taken, each of the photosites collects information about the light (or photons) that reaches it, including information about its color. This produces an electrical charge that is translated digitally by the camera. Pretty cool, huh?

Lens

The lens is the glass tube that connects to your camera's body. Depending on the type of lens your camera has, the tube may house several pieces of glass used to refract light in specific ways. Also within the tube are a series of blades that contract and expand to allow light into the body. The value of the opening in the blades is called the aperture, or f-stop. Aperture works in a very similar way to how the human eye operates, as we'll discuss later.

UMM . . . EXCUSE ME?!

If you're new to dedicated cameras and you've looked at a settings screen, you've probably seen something akin to ancient Greek staring back at you, taunting you into an apathetic stupor. I've been there! So before you decide to close this book FOREVER, let's go over the basics of this image and how all the settings play a part in creating awesome photos.

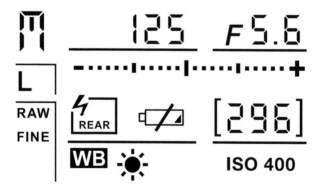

THE THREE MOST IMPORTANT VARIABLES

Shutter Speed

The "125" shown here is the shutter speed. It is often represented as a fraction, so if you see something like 1/60 or 1/500, that means 1/60th or 1/500th of a second. In virtually all cases with cat photography, you're going to be shooting at fractions of a second, so this 125 actually means 1/125th of a second. If your shutter speed shows an " mark next to the number on your camera, it means you are set to be shooting in whole seconds. You'll find out very quickly if you're making that mistake as you can audibly hear the delay when the shutter flips up and then flips back down.

As we noted earlier, the shutter's function is to let light into the camera, onto the sensor. We can think of the shutter as, as, well, an actual shutter. Imagine being indoors on a sunny day. You have some beautiful shutters lining your windows, and, at the moment, they're completely closed, not letting any light in. In this instance, we (the human observer)

can pretend to be the sensor. When we open the shutter, light pours in on us (the sensor), and when we close it, the light ceases.

Just as when you click to take a shot, this similar action takes place inside your camera. The shutter speed is precisely the length of time a shutter remains open to let light in. When you're shooting at 1/60, that means that the shutter is open for 1/60th of a second. This might seem like an exceptionally brief moment in time, but when you're photographing anything that is moving even slightly, this is rather slow!

Take these images, for example:

| 1/6th of a second | 1/500th of a second |

It's apparent that the first image has some blur to it. Why? Because during the 1/6th of a second that the shutter was open, there was movement; the cat was in motion, I was probably adjusting the camera slightly, the wind was blowing the trees, or the like. Even if your subject is incredibly still or sleeping, it can be challenging for the photographer to remain completely motionless for this length of time. All those micro-adjustments and small movements captured during that 1/6th of a second made it to the sensor, which is why it looks blurry. When the sensor captures photons moving across the frame (that is, your cat running around the room), it will show the photons' movement from point A to point B. This is what creates the blur.

To combat blur, we need to increase the shutter speed. Given proper lighting, we can freeze a great deal of motion at around 1/500th of a second. For slower or sleeping cats, a shutter speed as low as 1/60th can often get the job done with little to no motion blur.

You might be thinking, Wouldn't it make sense to always have our cameras set to 1/500th of a second? This way we would be ready to capture cats no matter what they were doing, right? It sounds nice enough, but nothing in photography is without a give-and-take. When we adjust the shutter speed to 1/500th of a second, the shutter will only be open for a very short time. This gives light a brief opportunity to make it onto the sensor, so unless there is an incredibly bright source of light, the subsequent photo will be dark and underexposed. If you're shooting outdoors in the sun, you're going to be well within your rights to shoot at 1/500th. But inside, at night—no way, José! There are few scenarios where something like this could work, but one way to help fix the problem of too little light is to modify the aperture.

Aperture

Whereas adjusting the shutter speed is something that takes place inside the camera body itself, aperture is local to the lens. Aperture, or f-stop, is a term used to describe the size of the hole in the lens that allows light to pass through. There are several blades inside the lens tube that either increase or decrease the hole's diameter. It looks something like this:

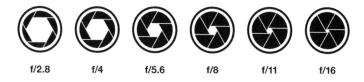

| f/2.8 | f/4 | f/5.6 | f/8 | f/11 | f/16 |

As you increase the aperture's number, the blades constrict, allowing less light into the camera, but providing a greater depth of field. The opposite remains true; the lower the number, the greater the light, the shallower the depth of field. Depth of field is a term used to signify how much of the focal plane is actually in focus.

Knowing what f-stop to use for a given situation will be critical to honing your own style, but also for getting clear shots. When you ready and focus your camera, the area selected becomes crisp. But you might notice that objects in front of or behind the focused subject are now hazy or slightly blurry. This is because of the aperture value. If you are using a low aperture value (for example, f/1.8) the depth of field around your object becomes very shallow, and you won't be able to pick up fine details outside of the immediate focal area.

I like to envision a vertical box extending forward and behind the object in focus. As you increase the aperture's number, the box extends more and more in both directions, allowing for a greater portion of the photo, or focal plane, to be crisp and detailed.

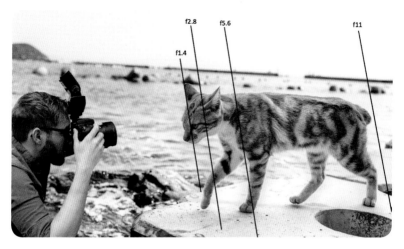

For demonstration purposes only . . . domestic cats are not this big!

Imagine that while taking a photo of a cat, our aperture is set to f/1.4. We start by lining up a shot near their nose and take the snap. What we'll encounter is that only a tiny portion of the face will be in focus. The shot will look like this:

This type of photo isolates only one small area or object in the scene, so we'll need to make some adjustments if we want to get more detail out of the cat's features. If we increase our aperture to f/4, we will now have more of the face in focus; potentially the eyes in addition to the nose.

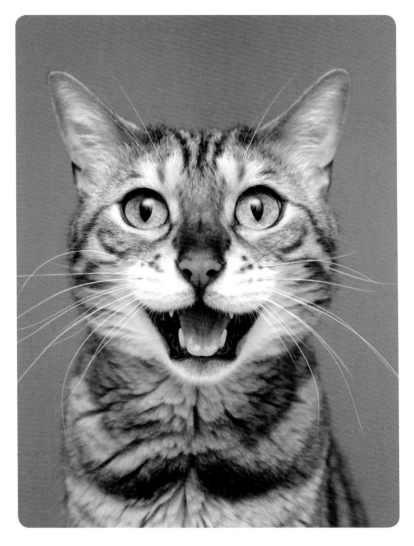

If we go higher, to f/5.6, as in the photo below, we'll get most of the facial features, including the head and ears in detail. And so on and so forth. By sticking to lower apertures (f/5.6 and below), we can really pick and choose what area we want in focus and draw the audience's attention accordingly.

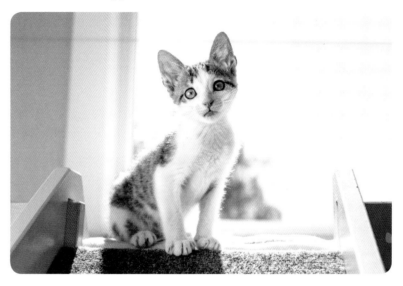

Each lens will have a minimum aperture listed on it, with some of the more common numbers being f/2.8, f/3.5, and f/4. There may also be a notation that the lens has a range (for example, f/3.5 to f/5.6). This is known as variable aperture. Variable aperture only occurs if you have a variable, or zoom, lens. Essentially, only the lower aperture number can be used if the lens is at its lowest, or widest, focal length. As you change your focal length and begin to zoom, the aperture will adjust automatically. This is generally an unfavorable feature, but can be unavoidable in much bigger lenses. You can get zoom lenses with fixed apertures (for example, always set to f/2.8 as its maximum aperture, irrespective of the focal length), but they will be considerably more expensive than those that are variable.

I'd be remiss not to mention bokeh here. It's pronounced similarly to the floral arrangement, bouquet. This is a really popular term used for the way an element of the image might look if it has a substantially low depth of field. It's most often noticeable in images with out-of-focus lights in the background, but can apply to all sorts of photos, assuming that the background is sufficiently out of focus or a substantial distance from the focal plane's box.

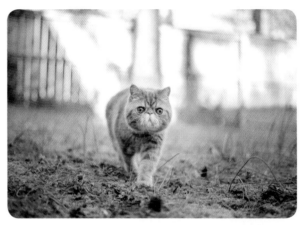

Beautiful bokeh, even for a pig!

ISO

Here's the final piece of the puzzle, and, fortunately for us, it's one of the easiest to understand and the simplest to modify to produce awesome shots. ISO stands for International Standards Organization. No, seriously, it does. It's the standardized scale by which we measure sensitivity to light. It should probably have a cooler name, but this is what we're left with, so we have to deal with it. If you've ever messed around with a film camera, you've probably noticed that the film itself has a specific ISO associated with it and that the ISO corresponds to the film's sensitivity to light, not the camera. The ISO we'll be referring to corresponds to your digital camera's sensor and its sensitivity.

If you refer back to the beginning of the chapter, where we talked about the anatomy of a camera, the sensor is the device that gathers photons and sends them to the processor to be translated into an image. Increasing the ISO allows the sensor to become more and more sensitive to the photons, resulting in a brighter, albeit slightly fuzzier, picture.

ISO usually starts at a pretty low number on your camera, in most cases around 60 to 100, but can go up to really high numbers, like 64,000. I'm not entirely sure in what situation you'd require something like 64K, but if you're trapped in a series of pitch-black underground tunnels and are trying to figure out what's making the unsettling grunting sounds a few feet away, I guess this could very well be your savior.

The unscientific way I like to think about ISO is that it creates artificial light to supplement the existing light in the environment. Now, this isn't pure magic without drawback. This comes at the cost of clarity, as the more you increase the ISO, the grainier the photo becomes. You can totally get away with using ISO in your shots, but don't go bonkers about it. I'd say do your best to keep it under 800.

If your camera supports it, you can also set your ISO to automatic. This will calculate what the camera perceives to be the best ISO for your situation, based on the two other variables of shutter speed and aperture. Auto-ISO is a helpful setting if you just want to set it and forget it. Don't forget that you have it on, though, as it usually won't correct itself if you use a flash. If you find that the auto-ISO feature lets you down, you can quickly retain control again by setting a definitive number. I really like to be able to fine-tune everything myself without the camera's suggestions.

Here's an example of cranking the ISO up just a bit too high:

Is this a photo of outer space? Naw, it's just a photo of one of our foster kittens at ludicrously high ISO.

When shooting in normal conditions with a decent amount of light, I try to keep my ISO as low as possible. You will start to encounter grain as you go up the scale, and while a little bit of grain is not unusual, it can become distracting to the eye if you go too high. The key to crisp photos is not only a shot that isn't blurry, but one that doesn't have a lot of noise, either. So let's do our best to keep it low. If you find that the only way you're able to get a well-exposed shot is by cranking the ISO to above 800, you're going to want to double-check your other settings and make sure they're in line with the environment.

As a quick side note, I think it's important to recognize the limitations of your equipment when compared to your environment. Even though you might have $5,000 worth of equipment, that doesn't mean that you're going to get the perfect shot you have in your mind. There will be scenarios where the light is so limiting that the only way you can capture a visible photo is to have blur or grain.

THE CAREFUL
ACT OF BALANCE

▬ • • • • • ▮ • • • • • ▮ • • • • • ▮ • • • • • ✚

Before we get too distracted by all the letters and numbers on the screen, the very first thing I'm going to draw attention to is the light meter. Every camera has a slightly different way of displaying the meter, but I want us to think of it like a seesaw.

In the center of the light meter is a 0 and the opposite ends are marked with ▬ and ✚ symbols. The ▬ correlates to darkness, while the ✚ correlates to brightness. For a properly exposed image, we will want the light meter's readout to be as close to 0 as possible.

Whenever we raise our camera to a scene, the light meter will begin to respond in real time to the amount of light it is perceiving with its current settings. You can wave the camera around, point it into direct light, cover the lens, and so on, and it will continue to calculate the exposure for the shot. Here are a couple of scenarios.

Daytime without Substantial Natural Light

Due to the lack of natural light, the seesaw meter is leaning far to the left into the realm of underexposure. A shot taken with these settings will result in extreme darkness. We will need to change something about our settings to get a well-lit photo.

The three primary players we will be concerned with are ISO, shutter speed, and aperture. We can increase one, two, or all three to achieve a well-balanced, illuminated shot.

If we take the previous example, we could choose to single out and only modify the ISO to make the picture brighter, but it will take a considerable increase of that variable to accurately balance the shot. While brighter, this will end up making the shot grainy.

2000 iso	1/250	f/3.5
—	0	+

Or, we could try to balance it by only modifying shutter speed. This runs the risk of making the shot blurry.

400 iso	1/125	f/2.8
—	0	+

Or, better yet, we could modify all three slightly, giving us the best opportunity to get a clear, crisp photo.

SHOOTING MODES

||

Most cameras have a couple of built-in shooting modes. Sometimes they'll have a graphic corresponding to them, like a flower, mountains, or a bunch of faceless gray humans. Weird. Anyway, they have very niche purposes that can be useful, but, hopefully, after you've put down this book, you can stop relying on them. They're usually pretty bad anyway, especially for cats. Here are some of the other modes we can select.

Automatic (Auto)

Aka, Jesus, take the wheel. You are at the whims of your device. Your camera will run some algorithms to determine the "best" settings to expose your shot and adjust the shutter speed, aperture, and ISO on its own. It's okay for stationary stuff, but if you're trying to capture movement, you're going to be totally out of luck.

Manual (M)

Aka, take the wheel. All the variables are under your control and you will have to manually (hence the name) figure out what settings to use to expose the shot. Definitely more advanced, but gives you total control over your camera.

If you're not yet comfortable shouldering the burden of all the settings, you can slip your camera into one of the priority modes, which can be an incredible way to get used to what the values mean and how to best adjust them. These are especially helpful in situations where lighting or motion are inconsistent.

Aperture Priority (A or A/V)

This mode allows you to manually set the aperture to a specific value that you want to keep as a constant. The camera will automatically change the shutter speed for the given environment, based on its calculations. I have found this mode to be extremely helpful when shooting outdoors and wanting to keep a specific depth of field throughout the shots. Outdoor lighting can be inconsistent, so if motion is not a big factor and you prefer to maintain one particular aperture setting, this is the mode for you!

Shutter Priority (S or T/V)

Very similar to aperture priority, but this allows you to manually set the shutter speed. Here's how I would use this: If you know you're going to be taking photos of a fast-moving subject, you can set your shutter speed high enough to freeze action, and the camera will adjust the aperture and ISO accordingly.

Now we're going to talk about a few other components on cameras and additional tools we can add to our kit. Proper knowledge of these will greatly enhance your ability to take awesome photos of your cat.

RAW
VERSUS JPEG

Before we march forward taking photos with dedicated cameras, I want to talk briefly about the differences in how you take and store your images. When we take photos with dedicated cameras, we can go into the settings and choose the format in which it is saved. There are a few formats we can use, but some of the most popular are JPEG and RAW. You may have heard of these already, but knowing the distinction between the two is significant.

With JPEG files, you're getting a smaller, faster file at the cost of reduced quality and information. This is because the image comes out compressed by your camera's software, which significantly reduces the amount of information relating to detail and color. If you ever want to edit your JPEG files, you will find it much more challenging to correct for exposure and color, and to bring out fine detail.

For us, one of the only positive aspects of JPEG files is that we can open them immediately with our computer or phone, and it won't require any additional processing to access and share them. RAW files are big and bulky, but they retain several times more information than JPEG files. This makes RAW a natural choice for photographers who wish to edit their photos and also gives the user much more leeway for mistakes, as you can correct far more with this format.

LENSES

There are *so* many lenses to choose from, and it can be overwhelming for someone new to photography. Whenever I look into buying a new lens, I read a ton of reviews before making a purchase. You can also opt to rent lenses from reputable companies and see if you like them before spending your hard-earned money. Lenses can range in price from under $50 to several thousand dollars. For bigger purchases, I wholeheartedly recommend renting first.

Focal Length

The first thing we're going to talk about with lenses is focal length. If you've ever eavesdropped on camera nerds, you may have heard things like "35 millimeter 1.4" or "24 to 70." The whole numbers they're referencing (35, 24 to 70) refer to the lens's focal length. The actual value of the focal length is kind of complicated: It's the distance between the meeting point of all the light rays within the lens and the sensor. Don't worry. We won't need to calculate or recall any of that. All we want to do is recognize how different focal lengths affect the look and feel of our pictures.

Here are some images taken with the exact same settings, but with different lenses. These lenses have different focal lengths.

16mm

24mm

35mm

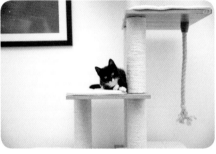
50mm

70mm

200mm

It might look like I'm just zooming in on a shot, but, again, these are taken with entirely different lenses. The focal length of a lens governs two main things: the field of view and magnification. Focal lengths can start at very low values, with the very shortest being at around 4mm. When you're using lenses at the low end of the spectrum, the field of view is extremely wide, enabling you to get much of the surrounding environment in the shot. Wide-angle lenses are often used for landscape and astrophotography because of this. As you go up in focal length, the field of view narrows, but the magnification increases.

Here's a crude depiction of what the field of view differences look like:

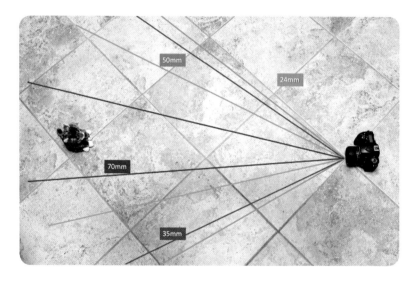

For a primary lens, I always suggest using something at 50mm or below. You'll want to have a lens that is wide enough to capture a range of motion if the cat is moving, as well as have room to showcase the background or environment if it enhances the overall shot.

Aperture

We covered this quite extensively earlier in the chapter, but if you need a quick refresher, every lens has a specified lowest aperture value, and this value is referenced on the lens. So, if I have a 35mm f/1.4 lens, the lowest aperture (or f-stop) it can go to is f/1.4. It's not fixed at this aperture, though, and can move freely in the other direction to the highest f-stop value of f/22. Big changes in the price point come when you get to very low aperture values. For instance, the difference between an f/1.8 lens and an f/1.4 lens can be hundreds, if not thousands of dollars.

Automatic versus Manual Focusing

The majority of modern-day lenses are automatic, but have the option of being used manually. Some individuals swear by using manual-focus lenses, which entails adjusting the focus ring before each shot, but I steer clear of this. Photographing cats is hard enough already. Unless I'm trying to do something incredibly specific, I don't add this extra hurdle. I have used a manual camera before and it is considerably more difficult to snap crystal-clear shots of nearby moving objects.

Prime versus Zoom Lenses

When I first heard of a prime lens, I was afraid to ask what it meant. I was under the impression that it was leftover lingo from the 1970s and it meant something like . . . a damn solid lens. It's *prime*, baby. Well, I'm not ashamed to say that I was wrong. So let me save you from the embarrassment in case you're wondering, too. A prime or fixed lens has a static focal length. If you pick up a 50mm lens, it won't be able to zoom in or zoom out. It stays 50mm forever, but that's okay. There are some beneficial aspects of prime lenses that help set them apart from their zoom counterparts.

Prime lenses are faster. They can go to extremely low aperture numbers. We're talking under f/1, which is nuts. They're called fast because their wide aperture will allow the camera to take photos at higher shutter speeds without compromising the frame's exposure. Additionally, if you're interested in taking pictures with creamy backgrounds and a shallow depth of field, you'll likely need a prime lens to pull off these shots consistently.

Zoom lenses give you a bit more flexibility, with the ability to zoom out to capture a whole scene or zoom in to specifically isolate a subject. If you're heading into a situation that you aren't familiar with, bring your zoom lens with you. It makes you nimbler and more adaptable if the environment isn't exactly what you expected.

FLASHDANCE

Onboard Flash

I've said it a bunch of times throughout the book, but we should do our best to avoid relying on any of our equipment's dedicated, onboard flashes as much as possible. They're just abysmal at getting photos of cats. To show you just how terrible we're talking:

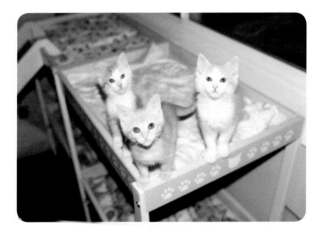

Yikes. This isn't the era of disposable cameras anymore. We don't have to live like this! My first suggestion is to throw down the money for an external flash. They can be as cheap as $30 and will be way, way, way, way more effective than the onboard counterpart. If I were to do it all over again, that would be the absolute first purchase I made after buying a camera body and lens. I understand working with a budget, though, so if you can't justify spending money on a flash, we can try to make the onboard flash work a bit better with the following camera hacks.

A component of most flashes is something called a bounce card. It's a small white piece of cardboard that can be lifted out of the flash and placed slightly into its trajectory. If you don't have a reflector on hand, this can be an attractive option. Unfortunately, there's a pretty big glaring (no pun intended) problem with using a bounce card for photographing our feline subjects. Their eyes!

I touched on the tapetum lucidum earlier in the book, and it will be seriously affected here if we use the bounce card. If you've forgotten, the tapetum lucidum is the layer in some animals' eyes that greatly reflects light. Any kind of direct, intense, flashing light will produce possessed, demonic kitty pictures. This is why it's so vital to diffuse the light before it gets to their eyes.

We can try two things: First, we can make a custom bounce card for the flash by using a small piece of paper or a business card. I recommend the latter for sturdiness. Pop up the flash on your camera, grab a business card, and place it next to the flash. Make two marks on the business card where the legs of the onboard flash line up. Grab some scissors and make two small cuts in the business card, only about an inch deep. Slide the business card into the flash, using the cuts in the card to slip over the legs. You now have a modified bounce card! This makes the majority of the light from the flash bounce upward instead of directly forward. It's not a terrific solution, but it works in a pinch.

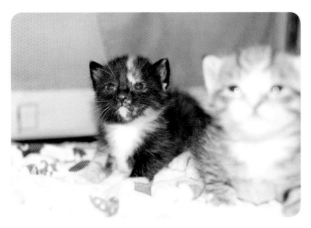

Business bounce before.

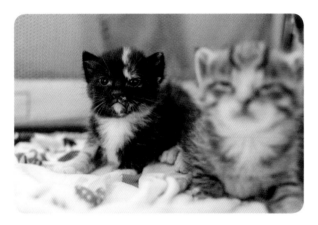

Business bounce after.

The other method is all about softening the harsh light instead of bouncing. This is way simpler than the business-card bounce hack. Pop up your onboard flash, then grab two tissues and a rubber band. Place the tissues over the flash and secure them with the rubber band, as in the photo on top of page 141. Again, it's not going be as effective as a proper bounce, but it will work wonders to diffuse the piercing brightness and make the photos somewhat usable.

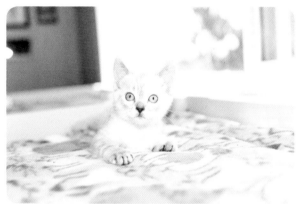

Without a tissue.

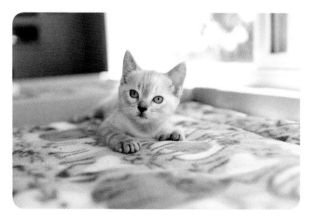

With a tissue.

External Flash

I'm really excited about this section because, to me, the external flash genuinely sets photos apart from others. These tips are like the delicious icing to my top-secret cake recipe. There are still some toppings to add, but we'll have a mighty fine cake after we get through this part. I've been told that if, for some reason, there were a cat photo lineup, my photos would be recognizable based on the lighting alone. I get loads of questions from people asking about my setup. If they only knew how basic it was!

Let's start whipping up that icing. One of the most useful features of an external flash is the ability to virtually bring your perfect lighting settings with you to each and every scenario. When we're dealing with predominantly indoor animals, being able to produce and shape light consistently with a flash is invaluable.

When you get your first bounce flash, you might be tempted to position it straight ahead. This looks like it would be its normal "resting" position. This is a total trap! Here's what a photo will turn out looking like if you take a shot with the flash facing forward. Absolute garbage and no better than the images taken with the onboard flash.

Not a good look at all.

And on page 144, at top, you'll see what it'll look like if you utilize the bounce mechanism and point it straight up. It's much, much better! But if you look closely, you'll notice that some of the cat's features just aren't showing up as you might like. The eyes are a bit shadowy and, even with editing tools, it can be difficult to reclaim the natural look. You could go in and tweak them, but it'll end up looking artificial.

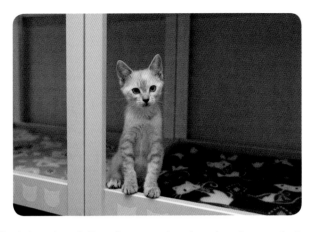

The flash is pointed directly upward and can't quite catch the eyes.

Here's part 1 of my method:

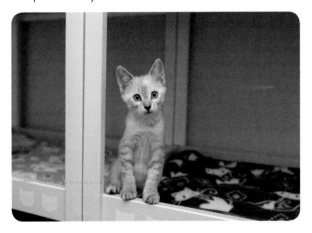

Angled back, even slightly, allows the light
to catch different surfaces.

It's a terribly slight adjustment—just 20 degrees back—but it makes
a world of difference.

Here's what it looks like now:

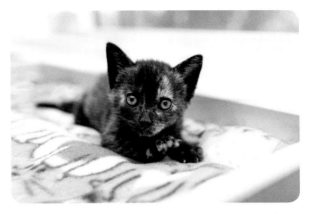

At an angle, the flash is able to catch the face and eyes!

When you angle it this way, light bounces all around a room much more equally. The reason for this is pretty simple. This is a weird one, but let's think of our flash like a launcher that shoots out a ton of tiny bouncy balls (photons) all at the same time. When we press the shutter, it triggers the launcher, and the bouncy balls are sent across the room toward the nearest wall or ceiling. The trajectory of those balls and their return path is based on the angle of the flash itself, the angle of the launcher relative to the wall, and the angle of the wall itself.

So in this scenario we're lined up, taking the photo of the cat, and the launcher (aka the flash) is pointed straight up in the air at the ceiling. When we take the picture, the balls go flying toward the ceiling and mostly come back down directly to their point of origin. Some might make a slight detour, but, for the most part, they're going to be sent down in the same way they went up. What this does in the case of a real flash is predominantly illuminate the top of the cat's head, but it will have more difficulty getting the eyes, the chest, or any other features that are not directly on the top of the cat.

When we tilt the flash backward just a bit, the angle at which it hits the wall will drastically change the trajectory of the photon bouncy balls

on their return. No longer will the light go directly back to the point of origin, but they'll spread and diffuse much more evenly. This will help illuminate the vast majority of the scene and bounce to catch areas that would otherwise be shadowed.

To consistently get shots that illuminate your cat's beautiful eyes, you'll have to angle your flash. Cats have a bunch of fur and lashes surrounding their eyes, as well as a slightly prominent brow. When angled, the bouncy photons work their magic and pop them right in the eyes. This bright look in their eyes, in particular, is called a catchlight. It happens when there's a dramatic highlight in the eye of your subject (that is, the area of the eye with the most robust reflection of light). It can happen indoors or outdoors, provided there's ample light at a trajectory that appropriately hits the eyes. This can have a pretty noticeable effect and helps call attention to the eyes in the scene. It has been known to help by connecting the audience to the subject. I don't know if that's true, but it looks cool.

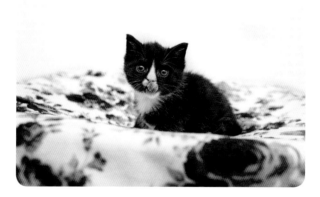

Shot is angled up toward the ceiling.

The second version of this method is to bounce the light more at a 90-degree angle to the closest adjacent wall and not the ceiling. We usually choose the nearest wall because the bounce's reflection will be more powerful the closer you are to it. Bouncy ball scenario again: If

we were to throw a ball with all our might at a wall 1 foot away and then throw one at a wall 20 feet away, the energy on the bounce from the closer wall would be greater. Before some physicist cracks his knuckles and writes my editor in protest, chill. The bouncy ball is just an analogy. The photons that scatter from the point of impact (say, the near wall) will stray far less before hitting that wall. Subsequently, there will be fewer stray photons on the return. The vast majority of photons will bounce back at your subject.

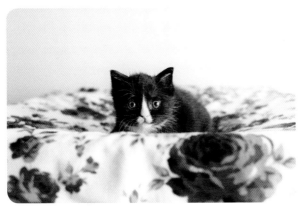

Shot is angled toward the closest wall (my right).

Similar to the straight up-and-down flash shot, you might notice that the sideways shot typically only illuminates half of your cat's face and body. This lighting style can be used to create a much more dramatic image. If you find that your photos are coming out as if your cat were Two-Face incarnate, you can try tilting your flash back just a bit from that 90-degree angle so that the ricochet is broader, or you can adjust your angle of shooting so that the wall isn't exactly parallel with your position.

Reflectors

In the accessories section about buying your first camera, coming up on page 158, I bring up reflectors and how, for $15, they can be a handy tool in your kit. The reflector's primary use is to, yep, reflect light. They're ubiquitous at fashion shoots and can be used both indoors and outdoors. For photo shoots with humans, you'll often see them hanging from a monopod or being held by a lackey on set close to the model, just outside the camera's view. They might have a gold or silver sleeve over them that will influence the color of the reflected light. We probably won't be using these sleeves, just the white ones!

Reflectors are flexible, literally. They can be bent to shape the way the light bounces off them to illuminate harder-to-reach spots or intensify light on a given area. This won't be easy to do alone if you're also holding the camera. If you have a friend who wants to help out with your photo shoots, this is something they could do with you. I only use reflectors in very specific scenarios, and I always use them to help supplement my flash. Some of the environments where I recommend them are indoor spaces with high ceilings, distant walls, and/or very vibrant-colored wallpaper. Also, if it's dark outdoors, it can be useful to use a reflector.

In the biggest of pinches (and, yes, I've done this multiple times), you can use a piece of white or gray material, hold it out as far as you can from the flash's projectile path, and take a shot. This will help reflect, diffuse, shape, and bounce the light in sticky situations. At the top of the facing page is a photo I took at a cat beach in Malaysia.

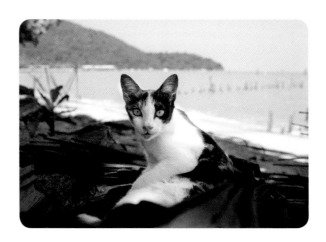

I was having a lot of difficulty getting the light just right. It was outdoors, over 90°F, and extremely sunny out. There were numerous highlights and lowlights in the shot, due to the nature of the sun, clouds, and shade from the tree. The stars really had to align for each shot to come out well, and, with limited time, I didn't have the ability to blast photos for several hours until I got "the" shot. I had to think on my feet!

I wanted to be able to have the background visible in the frame because of how much it told the story of being on a tropical beach. But I was having difficulty doing this without blowing out the shore's details or underexposing the cat. Here's where the flash would reign supreme, but—whoops, silly me—I didn't bring a reflector with me to Malaysia, and I didn't have any paper in my backpack. Fortunately, I discovered a small, unused gray cat bed nearby. I picked it up, made it into a more manageable square shape, and extended my arm to use it as a reflector. I started taking shots, and you can see the result here! Just as easy as that, the cat bed became my reflector and allowed me to produce some awesome shots.

Another reason you might use a reflector: the color of the walls in a given space. An unfortunate caveat to shooting with a flash is that whatever the flash hits and bounces off will affect the temperature of the shot. So, if you're shooting in a house with vibrant paint on the walls,

you're going to be doing a lot of color correcting in postproduction, or shooting predominantly with a reflector. Here's an example of a shot in a house with yellow paint on the walls.

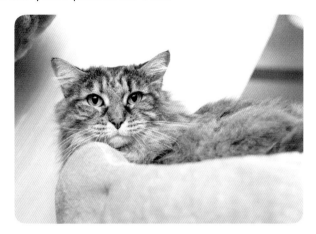

Before any editing, you can immediately tell that there's a great deal of color bleed in the photo. The paint has tainted all other colors in the scene, making them much more yellow than they ought to be. The same would happen in a very blue, green, or pink house. In editing programs, you can fix the white balance here, but it can be time-consuming to adjust every color to its correct shade. I can tell you from personal experience that it can take a long time to fix the intricate hues of a cat, and the shot never seems to be quite right. If your house has vibrant-colored walls, don't be discouraged. You'll just have to become well acquainted with your reflector or a master of editing.

In the next section, I want to show some examples of my photos and give the reasoning for the settings I used. You can use these settings as a baseline for your own.

PRESETS

I'm going to take some of the guesswork out of your shots with your dedicated camera. The exact settings will vary depending on your environment, but here are some high-level suggestions of where your settings should land.

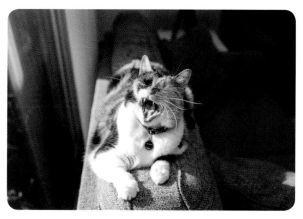

Indoors with Ample Natural Light

Settings—Shutter speed: 1/160; Aperture: f/2.8–f/4; ISO: 200

This is one of my favorite ways to shoot. Early on we covered how effective natural light can be at illuminating the scene and giving you true, beautiful colors. Nice daytime light makes taking awesome shots a breeze. For settings, you'll need a quick shutter speed if you intend to capture any kind of motion. You could get away with a slower speed if your cat was sluggish or sedentary, but a good general starting point is 1/160. If you're photographing a cat who is running all over the place, you may find that the 1/160 is still producing blurry shots. Continue to modify your shutter speed until you're able to get the photo without much

motion blur. Alternatively, you can use some of the attention-grabbing techniques from chapter 1 to command your cat's attention long enough to take the shot.

The aperture at f/2.8 is sufficient to capture most of your cat in focus, but feel free to drop it as low as your lens allows. On the higher end, I wouldn't go much more than f/4, because you run the risk of letting in far too little light to actually capture the photo. The ISO won't matter all that much and can be adjusted slightly to compensate for missing light.

Indoors Freeze-Frame

Settings—Shutter speed: 1/250; Aperture: f/4; ISO: 100;
Flash: 1/4th Power

These settings look quite a bit like the indoors with natural light shot, but with one significant difference: the introduction of a flash. We talked a lot about flashes and how they work, so now's your opportunity to take photos like this.

If you're looking at the shutter speed and thinking that 1/250th of a second isn't fast enough to capture insanely fast motion, you're right. The only way we're able to accomplish this is due to the way the flash operates and its ability to freeze action. With the flash providing a ton of extra light, we can feel free to increase the aperture and lower the ISO to as low as it can go on our camera. This will ensure some of the crispest shots your camera can get, because little to no increased ISO will reduce the amount of noise, or graininess in your image. If you find that your flash is providing too much light with these settings, you can (1) reduce the power on your flash or (2) increase the aperture to get more of your subject in focus and reduce the amount of light let into the sensor. At this point, it's up to you to decide if you want a more blurred-out bokeh background or a deeper focus box.

Outdoors Shot with Direct Sunlight

Settings—Shutter speed: 1/500–1/8000; Aperture: f/4; ISO: 100

This will likely be the least common way we end up shooting, but it's still important to have in our arsenal. As you can see, the shutter speed variance here is pretty massive. The amount of light we experience outdoors

will really determine how much we're going to have to fiddle with that number, especially if there are intermittent clouds or pockets of shade. It's one of the most challenging environments, due to how often you'll need to swap up your approach. On a sunny summer day, you might end up shooting at 1/2000 or higher to maintain the lower aperture number. Keep your ISO as low as it can go, because direct sunlight will provide more than enough illumination for your shots.

Outdoors Shot with Indirect Sunlight

Settings—Shutter speed: 1/250–1/500; Aperture: f/4; ISO: 160

These are shots where the sun isn't directly in your subject's face. They're not eclipsing the light, but they're off to the side of the primary light source. We'll end up treating this a lot like an indoor shot, but with slightly more access to ambient, environmental light.

Now that you've gotten an idea of what kinds of shots can be produced with dedicated cameras, and what the settings do, I hope I've piqued your interest! The next section explores more of the nuances of dedicated cameras when you're shopping for your very first one.

SHOPPING FOR YOUR FIRST DEDICATED CAMERA

Being new to the world of dedicated cameras can be daunting. There are lots of brands, models, lenses, and numbers to sort through. The numbers can be especially frightening when they're representing dollars. Dedicated cameras aren't cheap! That's why it's so important for you to be well informed before you pull the trigger and make a purchase.

First and foremost, visualize your goals for this camera. Are you an aspiring photographer looking to do some part-time work? Is this solely for amusement with your cat? Do you intend to do video? Are you going to be traveling a lot with it? Are you a professional looking for an upgrade? These are just a few questions you should ask yourself, as they will play a vital role in determining the right kind of camera for you.

The next most important question is this: What's your budget? Few of us have an unlimited budget, but even if we did, the absolute most expensive camera might not be the right one for our needs. Making a list of your goals and then writing down your preferred amount to spend is a great start. You'll automatically qualify or disqualify a large number of cameras based on budget alone.

Let's say you have $1,200 to spend on a camera and its accessories. You're looking to start taking photos of your animals and others for fun. This is how I'd proceed . . .

Camera Body: $600–$700

I'd look for something that has reasonably good reviews and picture quality, especially in low light. There are tons of forums and review sites on the web that give very detailed information and sample photos for almost every camera on and off the market. Reading reviews by industry professionals was how I found what camera was right for me. Additionally, look for a camera that will produce pictures with at least 20 MP. This will allow you to make prints without sacrificing image quality. Some brands are better for video, too, so keep that in mind if shooting video is in your future.

Lenses

While having a powerful camera body is significant, probably the most impactful and lasting way to spend your money is on the lenses. You'll eventually upgrade your camera's body, but your lenses can last forever, as long as you stay with the same brand. I'd budget one-third to one-half of the balance of your budget for your lenses. You can usually get a good deal on a body-plus-lens combo, but more often than not, the "kit lens" is not that great or worth the deal. If it's only around a $50 difference, it might be worth springing for the premade kit and taking the additional kit lens. Anything more than that and I would double-check prices. Your money can go a lot further if you hold out for a more expensive, quality purchase.

Lens choice is critical. If you need to, go back and refer to the section on focal length (page 133). You'll want to grab at least one lens that's 50mm or lower. Anything higher than that, and you will experience a lot of difficulty getting the entire cat into the frame, due to

the magnification. Remember, the lower the focal length, the wider the field of view. If you're indoors, you'll need something wide, especially if the cat is moving around a lot or coming close to the camera.

For the $1,200 budget, my recommendation is a 35mm or 50mm, f/1.8 prime lens as your primary lens and an 18–55mm zoom lens. The range of 35mm to 50mm is most similar to how human eyes see, so that's why photos taken at that length tend to look especially visually appealing. If you went with a cheaper zoom, the aperture on the zoom lens may be variable, automatically adjusting the low end of the aperture as you zoom in and out.

Lenses are typically brand-specific and won't work on other camera bodies, so choose your brand wisely! As you amass your lens collection, it will become that much more difficult to swap brands if you're so inclined. It's a good idea to stick with tried-and-true companies that have been around for a while, especially because their used lenses are much more prevalent on aftermarket websites.

You'll also be able to find "off-brand" lenses that are not made by the same company as the body. These are slightly more affordable, and, depending on the lens, can be just as good as their brand-name counterparts. Most of my first lenses were used and off-brand. It was a great way to get my foot in the door and use more professional equipment without paying staggering costs.

Okay, we've spent $700 on the body and $300 on lenses. We're nearly set! The last few accessories will really put the finishing touches on your new purchase and set you up for success.

Accessorize Your Life

First, you'll want to get a relatively big and fast-writing memory card now that you're going to be shooting in RAW format, which takes up much more space than JPEG. I wouldn't go lower than 64GB unless you want to be dumping your memory card onto your computer after each shoot. The speed of the memory card also matters. Have you ever taken a burst of photos and had to wait a few seconds to see the image on your camera? That's due to the speed of the card you're using. The speed will also come into play when you import your photos to your computer or smartphone.

Next, grab yourself a flash. Onboard camera flashes are notoriously terrible, and you might as well pretend that the onboard flash doesn't exist on your camera. In fact, many companies no longer even bother to install an onboard flash on their cameras anymore. For external flashes, or speedlights, you'll notice that their prices vary greatly, but even a cheap flash ($30) will give you the ability to experiment with a real game-changing piece of equipment. Flashes open up the possibility of shooting in virtually all scenarios and environments where low light would typically make it much too challenging to get a clear shot. As you go up in price with flashes, there are a few things to watch out for. You'll want to get a bounce flash. Fortunately, the vast majority of flashes on the market have the ability to bounce, but some are static in their position.

A bounce flash looks like this:

You can modify the way in which the light will be projected and thus reflected. Bouncing the flash is crucial, as a direct flash on cats' faces will not only wash out their colors, but it will create an unflattering shine to their eyes. The next thing you'll want to check out on the flash is its "recycle time." This is how long it takes for a flash when at full power to project its light and then fully recycle to be used again. Recycle time goes down as price goes up.

I use a flash that has a rapid recovery time, because of the burst style way I prefer shooting. The overall power of the flash is slightly less important because you'll mostly be bouncing it and reflecting it off walls and objects in order to slightly diffuse the luminance. Those are the needs for a decent flash. I'll cover much more on flashes and the most practical ways to utilize them in an upcoming section.

Grab a reflector. For our size needs, they're under $20. You won't end up using this too often, but in cases where you wind up in a room with very vibrant colors or with cavernous

ceilings and distant walls, you'll be so happy you have this to help bounce the flash.

With your remaining money, budget a decent editing program for your photos. Surprisingly, around 50 percent of my overall workload happens long after I've taken the picture. Learning how to edit your photos properly is essential to creating awesome shots that stand out. There are some free programs for phones and computers to help get you acquainted with the process, but the real deal comes when you spend a bit of money. Paid programs like Lightroom are powerful and transformative. You'll notice a distinct difference from the free software after editing your very first photo.

The last element that I want to touch on is batteries. The majority of flashes take AAs and are notorious for chewing through them quickly, creating a massive dent in your wallet and unsustainable use of the planet's resources. I highly, highly recommend investing in high-performance, rechargeable batteries and an eight-battery rechargeable station. There are a couple of brands that specialize in batteries for electronic devices and these work surprisingly well. I was skeptical of their price tag and performance initially, but I am a total convert now.

YOU'VE GOT THIS IN THE BAG

Coming well prepared to a photo shoot is essential to success. I want to show you guys what I bring with me when I travel for a shoot and what I have on hand when I'm taking photos in my own home. A lot of this is an accumulation of the items discussed earlier on, with some helpful tips and suggestions for things you may not have considered.

The most obvious: You'll want to bring your camera to the photo shoot. Big brain stuff here, right? I'm not ashamed to admit that I've forgotten my camera before, but fortunately didn't make it all the way to the shoot before that dawned on me. Also, make sure that before you leave the house you have your primary memory card seated inside the camera, ready to go, and one additional card tucked away in your bag.

It's an unfortunate reality, but things break and die all the time. A card that may have been working correctly a few hours ago can quickly decide to fail you. If you're out on an assignment and suddenly realize that you can't take a single shot, you've just wasted a huge amount of time for you and the client. Having a cheap, backup memory card for situations like this will eventually pay for itself and bail you out of a rough situation. Something going awry with my memory card happens at least once a year, and I'm always grateful that I have a backup.

Have at least one, if not two, fully charged spare camera batteries in your pack. Same philosophy as above. Batteries have a shelf life, and the more you recharge them, eventually the less power they retain between each charge. You might not have noticed it, but your battery that used to last for 2,000 shots can now only sustain 200. That's a radical difference, and you won't want to be caught out on a shoot with a sliver of battery life left. I have a small charging station in my office, where I keep batteries of all kinds fully charged and rotating between sessions.

For lenses, I like to bring my most used lens and one additional lens just in case something happens to the primary lens, or the situation calls for something more specialized. The extra lens I bring is the variable, zoom type. It'll work better in niche environments and is almost as powerful as my primary lens for general photography.

For lighting, I bring my flash, one or two additional sets of AA batteries, a small LED light, and a reflector. I don't often use the LED light, but if I do, it's used for "fill light."

Cheap LED lights like this can be helpful for giving you a boost of light in a darker scene.

The rest of my bag is filled with toys and treats. A few crinkle balls, plastic balls with bells, and wand toys are an absolute necessity for grabbing attention and getting the cats to work with you. As far as treats, I usually bring a pack of snacks and a tub of catnip. These can be used as last-resort bartering tactics if your subject is seriously not interested in participating. Food and catnip can also be a great way to mix up the shots you're taking. A lot of funny, unexpected moments occur when cats are eating, licking their lips, or rolling in catnip. See my last book: *Cats on Catnip*!

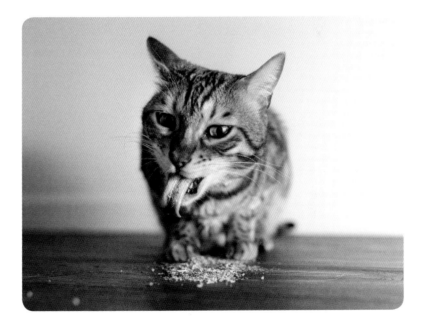

Another thing that I can recommend if you're on the go a lot is a Wi-Fi-enabled memory card or a memory card adapter for your phone. If you're taking a big trip and don't want to bring your computer with you, this is the ticket. There are many mobile apps that include powerful editing tools, so you won't even need to bulk up your bag with a laptop if you want to share photos while traveling.

Chapter 5

Editing

Look at us! We're well over halfway through the book and on our way to achieving awesome photos of cats. We've painstakingly learned the ins and outs of our equipment, figured out how all the various settings affect one another, and now we're coming up on one of the most important chapters. Editing! Listen, we can get virtually everything right mechanically and still have room for improvement during this process. There are instances when our photos look absolutely beautiful and can be used straight from the camera, but, most of the time, we're going to need to touch up our photos just a little bit.

Just as we broke down all the sections in the Photography 101 chapter, I'm going to walk you through the main points when it comes to editing, and give examples of common problems and how to fix them. Before we get our hopes up, a brief disclaimer: Editing can enhance, perfect, and heavily modify a photo in magnificent ways. It can save a picture from the brink of deletion, *but* it cannot resurrect a dead shot. We're photographers, not miracle workers. Dead shots are those that are out of focus, blurry, way too bright, or way too dark. I'd be inclined to include in this category shots that have an excessive amount of color bleed, as they're often not worth the effort it takes to correct them.

As you're taking photos, it's a good idea to review your shots, and, when you spot these dead frames, delete them immediately. They're helpful as a reference to what went wrong, but they're just going to take up valuable space on your memory card and bum you out when you go to import or post them later on.

FIXING EXPOSURE

Exposure is the very first thing I address when starting the editing process. Unless you're shooting indoors with consistent lighting and stationary equipment, every photo in the batch is likely to have slightly different levels of exposure. Fortunately, it's really easy to fix exposure with editing tools. As I mentioned in chapter 2, when we're taking photos, our goal is to expose to the highlights. If we were unsuccessful in doing so at the time of shooting, this is where we can make up for it. We should edit just enough so that the peaks of the highlights in the shot are visible (assuming there's detail or content in them) and so that there aren't large areas of shadow or darkness.

Let's look at a likely example. ·

Clearly, there is insufficient light in the top frame on the facing page. The subject is shadowy and the details are difficult to see. This is a crappy photo, at least at the time it was taken. By adjusting the exposure in this shot below, look how much better it becomes. We've hit this picture with the heart paddles and brought it back to life!

Virtually all photo editing and social media programs have the ability to adjust exposure, but in those programs it might be called something different, like Brightness. It's essentially the same thing.

From shadowy . . .

. . . to brilliant!

FIXING WHITE BALANCE

Perfecting your photo's white balance is a slightly more complicated process than modifying exposure. You might have to rely on specialized tools or a keen naked eye to ensure that the white balance of your photo is correct. When you're editing the white balance, you do this by changing the "temperature" or overall coloration of the shot. Every photo you take has a corresponding temperature reading, and the goal of balancing is to neutralize external factors that may have altered the true colors.

When you bring up your picture in a program, most tools will have the starting position in the middle of a slider. By moving left with the slider, you change the temperature to be bluer, or cooler. To the right, you'll make the shot warmer. I often have to find the correct balance manually. I do this by first sliding far left and slowly dragging the slider to the right. Once I've found what appears to be a more accurate coloration, I'll stop and then compare the new color scheme to what the original photo looked like. I repeat this process a few times until I can be sure that the new white balance isn't too dramatic and displays the other colors correctly.

If you're using a more advanced program, I recommend playing around with a white balance dropper tool. This works by placing the dropper on an area of the photo that is meant to be white or, at the very least, neutral. If your photo has a white door frame in the background, or there's a patch of fur on your cat that is light, you can place the dropper over that area and use it as an anchor point. It often requires a bit more manual refinement, but this is a great starting point.

In a house with yellow walls, the light will almost always affect the photo.

It may not be readily apparent, but the temperature of this photo is extremely yellow. It's really distant from the true white we're after, and, personally, I think it gives the picture an unclean look. I understand the utility of yellow-tinted lights in places like the bedroom, but I really despise warm lights everywhere else. Sorry! Fortunately, if your house is filled with yellow lights, you can pretty quickly fix this by adjusting the temperature in postproduction.

Very yellow photos can be easily balanced in post.

With adjustments in those two areas, you will begin to see a considerable improvement in your photos. Editing entails a whole lot more than just exposure and white balance, and you can choose to get highly invested in specific images, spending hours on a shot. This is very far from my method of editing. I don't do much Photoshopping or graphic design, so I streamline my editing process to be as quick and efficient as possible. I'm going to run down all the rest of the sliders you commonly see in editing apps and show you how they affect the photo.

Contrast

This makes the blacks blacker and the whites whiter. By increasing the contrast, you can make an image pop by enhancing more of the defining lines and characteristics of your cat. If you decrease the contrast, you'll end up with less distinct blacks and whites. This tends to make the image a bit hazier, as it moves everything black and white into the realm of grays.

Little contrast.

Contrast turned up significantly.

Highlights

Similar to exposure, but different in one key aspect. It will only increase or decrease the already white, or brighter, parts of an image. This can be very helpful when enhancing detail in white cats, objects, or clouds. Sometimes when you increase the illumination of the entire picture with brightness, it will overexpose the preexisting bright spots. Here, you can decrease highlights to maintain a bright shot, but still manage to show all the precious details.

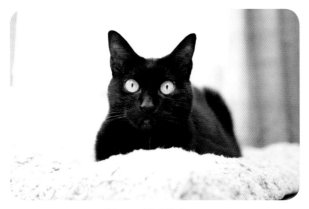

Heavy highlights.

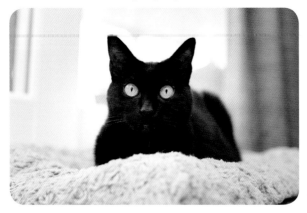

Highlights turned down; check out the window behind the cat.

Shadows

Basically, the opposite of highlights. Shadows affect all the black or darker parts of an image. By increasing or decreasing the shadows, you can hide darker details or bring them out. This is especially useful when dealing with black cats! A well-exposed image might still have a great deal of darkness and shadow enshrouding your cat's features. By moving the shadows slider to the right, you can bring out way more detail without overexposing the rest of the shot.

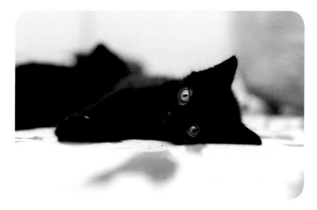

Heavily shadowed.

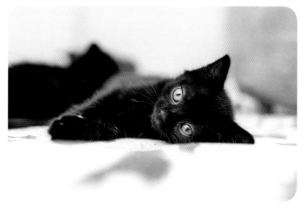

Shadows lifted to reveal details.

Clarity / Sharpen

I use this tool on pretty much every photo I take. It increases the definition of anything textured. When we're talking about a cat's face with thousands of hairs, intricate patterns, and beautiful eyes, this is a clear win for us. It doesn't improve anything that wasn't already there, so it's not as if we're doing anything sly. We're merely making some of the detailed features more pronounced.

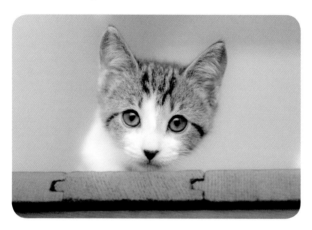

Soft and smooth.

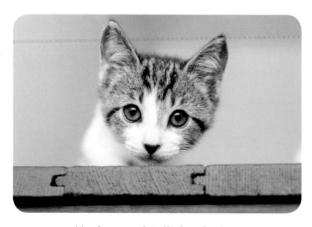

Much more detailed and crisp.

Texture / Structure

This is somewhat similar to clarity, but I tend to stay away from this tool. Instead of increasing the definition of anything textured, it increases the definition of everything in the frame. Unless you're working with a really dull image, I would recommend using this sparingly. If you get too heavy-handed with this tool, you will severely ruin your image.

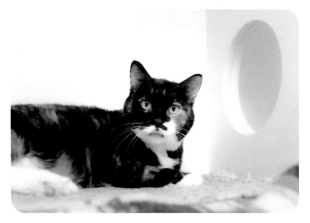

Little form or definition.

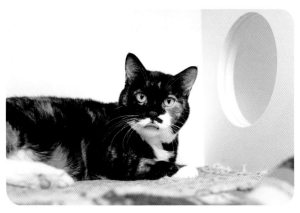

Many hard lines and defined textures.

Saturation

Increasing this slider will make all the colors more vivid. You can very easily overwhelm the picture if you're too generous with its usage, so please be careful here. When I'm looking to adjust the saturation of a photo, I often get it to where I think it looks natural and write down the value. Then I'll drop it all the way to 0, or black and white, and work my way back up to what I think looks good and note that value. I then try to find a nice middle ground between the first and second values. It's not rocket science, but if you can take an extra minute to balance the saturation properly, you'll ensure that the enhancement looks natural.

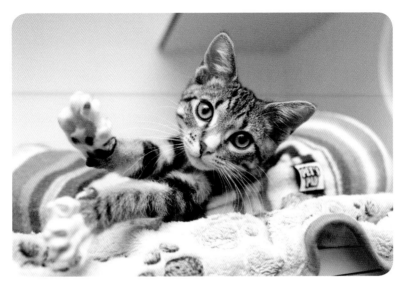

A bit dull.

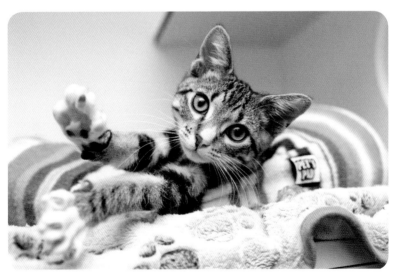

Colors popping off the page!

CLONE. IT. OUT.

One of our close friends in the rescue world remarked to us that our kittens always look so clean and perfect in photos. He wanted to know our secret! Well, we were flattered, sort of. While we certainly take pride in keeping our fosters nice and tidy, the honest truth is this: editing. I sometimes spend an excessive amount of time editing out all the little crusty bits off our kittens. They don't have any awareness to clean themselves yet, so whatever we end up missing stays on them.

Even so, the high definition of today's cameras will show details that you probably wish you couldn't see. You'll find with your own cat that they can end up having a veritable troop of nose and eye boogers clinging to their face at any given moment. And don't even get me started on butts. Many long-haired cats suffer from perpetual "poopy emergencies," and we may not notice just how filthy they are until after we've taken the shot. This is where cloning and healing tools reign supreme.

I primarily use a paid computer program to do my editing, but there are a few free beauty apps that can do spot treatment to fix "blemishes." These apps use an algorithm to determine an alternate spot from which to borrow texture. Just as we might clone out a zit to even our skin tone, we can clone out eye boogers and replace that spot with another area of the cat's hair. I usually pick areas very close to the original location, because the pattern of the hair will be most similar.

I've even been known to clone out buttholes from photos if they're too prominent. I'll just add some additional fuzz from the surrounding area to "conceal" them. If you look at the photos in my book *Shop Cats of New York*, you might find that, surprisingly, none of the cats have them. Gasp! We shouldn't be grossed out by the anatomy of a living being, especially if they're our best friends, but I don't necessarily want to look right at it, either.

The clone tool can be used for all sorts of things that are unsightly in a shot. If there's litter on the ground, *boom*, gone. If there's a bunch of cat hair strewn around, *boom*, gone. Objects on the wall, gone. You can even clone out people if you spend enough time on an image. It's super, super helpful to spruce up the shot and gives your cat a bit of undeserved good hygiene.

Before the edit "bath"; lots of crusty bits and unsightly spots. This is easily remedied and will make a big difference in the outcome.

Look at how clean this kitten just became! You should try to wipe away the crusties before a shoot, but this is our secret weapon if we forget.

ADVANCED TIPS

I want to give a few quick tips to the more advanced users of paid pro-grams. Most of the basics we covered can be accomplished with free phone apps, but the following editing methods will usually require a license for or a subscription to a more complex application. If you're keen on becoming a hobbyist photographer or taking the next step to enhancing your photos, you will most definitely want to look into this as an option.

Brushes

This tool is almost like painting with light. You can sculpt, color, brighten, and enhance areas of a photo with pixel-point accuracy. It's akin to having a digital pen with editing sliders for all the variables cited above (temperature, exposure, saturation, etc.), and being able to draw onto the photo with these discrete settings. I use this tool primarily to even out the coloration, to highlight or darken small areas, and to brighten eyes.

Before using the brush tool.

After using the brush tool; notice the eyes.

Filters

Much like brushes, filters can be used to improve a specific area discretely without affecting the entire photo. My tip to using these is to pull out the radial filter; increase the highlights, exposure, and saturation somewhat; and place the filter in a big circle around the subject. Tweak the settings a bit so it doesn't look too apparent that you threw some extra editing at it. The goal is to further enhance the lighting on the subject, making it appear as if the light source illuminating the cat was a bit more powerful or came from an additional angle. If you ever have a photo with multiple cats and one of them didn't catch the light, you can place a radial filter on them, and it'll make it look as though they have their own individual light source.

Without a filter.

With a circular radial filter for exposure.

BEFORE
AND AFTER

Eyes get tired. They also become habituated to colors and illumination levels. If you're doing a huge batch of photos, I don't recommend doing any more than half in one sitting. In fact, I suggest that you go to sleep or take a long break in between editing so that when you return to the photos, you come at them with fresh eyes. You might be surprised to see that all the images you've been editing have had their white balance slightly off and require further adjustment. Also, if you're ever unsure about your edit, save the shot when you reach a point where you think it is complete. Then reedit that same photo and cross-reference it against the other. What features are different? Which do you prefer? It might be an amalgamation of the two and require a third edit. By taking just a few minutes to edit your shots, you can completely transform photos you may have thought unsalvageable into masterpieces.

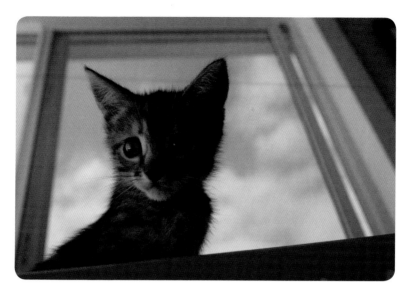

Here's where you can really see the power of editing.

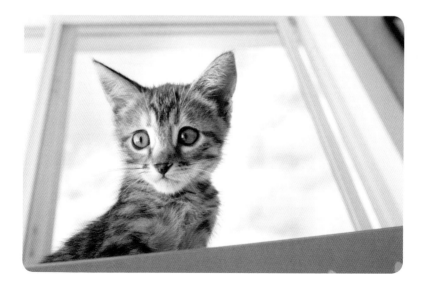

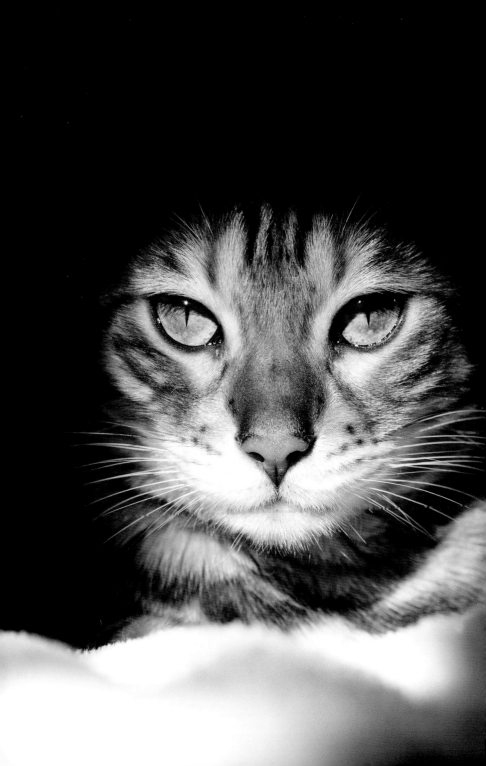

Chapter 6

Putting Your Awesome Photos to Use!

Mission accomplished! We have learned how to handle cats, take beautiful photos of them, and edit them to perfection. I'm proud of you! I hope you're proud, too. Now that we're pretty well accustomed to taking photos that look good, I want to explore all the ways in which we can leverage our pictures in the real world and make them count. We can, of course, keep the hoard of perfect pics to ourselves, but I would highly encourage you to let the rest of the world in on the secret. Your cat is incredible, and you take amazing photos!

This chapter is all about ways in which you can put your newfound skills to use. I would assume that most of you are interested in sharing photos of your cat with your family, friends, and even strangers on social media, so that's where we're going to start. Social media is an excellent home for your shots, but I hope that what you do with them doesn't end by posting them online. I'll round out the chapter with a few helpful suggestions and tips on ways to branch out with your skills. You can do a lot of good out there if you're up for it!

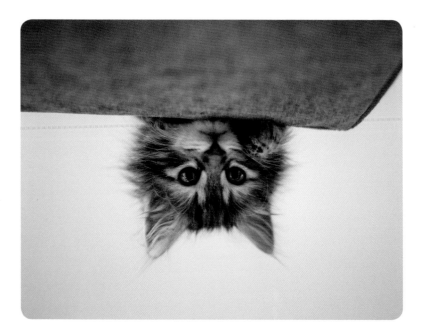

JUST FOR FUN

Whether or not you charge for this stuff is entirely up to you, but I want to give you some creative ideas for photo shoots that I've done in the past.

Engagement

How cute is this?!

Well, this was the first and only engagement shoot I've done so far, but what a blast it was! With your skills, you can put a "cat spin" on everything you do now. I was approached by these former adopters of ours to do an engagement shoot, but they wanted it to be lighthearted and involve the cats. So, I went out to a local craft store, bought some of the traditional cheesy engagement shoot props, and really leaned into it. We had an incredible time! It turned out so beautiful and felt completely organic. At the end of the shoot, I rounded things out with a bit of catnip, just so the cats didn't feel like they weren't also being celebrated.

Holiday Shoot

Our pets are family, and sometimes even more important than the humans who share the same title. Take a traditional photo shoot, like your Christmas card, and give it some unexpected flair by including the cats.

He loved it, I swear.

This shot not only raised more than a handful of eyebrows from family members, but was the first photo my now-fiancée saw of me, and the impetus to asking me out on a date. One man's absurdly silly joke is another man's siren song. Something like that. Anyway, adding a cat to what would typically be a run-of-the-mill holiday shoot is a great way to enhance the outcome and give a card worth sticking on the fridge. If you take time to set up a backdrop and lighting, it'll be easy to invite others over and make cards for everyone. Just be sure their cat is cool with traveling, or you'll end up with a very red Christmas. If you know what I mean.

New Kitten Shoot

You know those really common shoots people have done when they bring their newborn babies home? Swap out the human and put a cat in its place. Now we're talking! Make sure you have a bunch of blankets and soft lights. Use portrait mode on your phone, or bring down the f-stop to a low number on your dedicated camera so that the resulting photos have a soft and pleasant background.

Gifts

People absolutely *love* photos of their animals. If you're looking for a cheap and meaningful gift to give someone, gift them a short photo shoot! In cases where people are difficult to shop for, this is a terrific way to express your gratitude toward them without breaking the bank.

If you're willing to go the extra mile, you can use the photos you've taken and get them professionally printed and framed. This is, by its very nature, a once-in-a-lifetime, unique gift. I cannot begin to describe how grateful those who have received a photo shoot as a present have been, especially if their animals are getting on the older side. Being able to preserve a memory forever with your skills is unlike anything else you could give them.

IT'S BUSINESS TIME

We don't always have to be selfless, magnanimous beings—we also have to pay the bills! I get a lot of inquiries from people looking to start a pet photography business and are curious to know the best way to go about it. Pet photography has been around for a while—much longer than I've been doing it—but I can talk a bit about how I got my start and what worked most effectively for me.

When I realized that I wanted to pursue photography as a part-time job, I began building a strong portfolio. That became critical to showcasing my work. It's great to have hundreds of photos of your own cats, but potential clients are interested in seeing your skills applied to an array of situations, environments, personalities, age ranges, and even other types of animals. I gladly took as many photos of dogs as I could when I first started out. It did not pay to be picky!

Very early on, I offered heavily discounted or free shoots to friends and family. It was vital to capture as many photos of cats as possible, so I didn't mind doing the shoots for free. Plus, I needed the work experience. There is considerably less pressure and fewer repercussions if you botch a shoot at your friend's house than if you were to make the same mistakes out on a session where clients are paying you for your time.

When I got started, I was finishing school in Philadelphia and had a few part-time jobs on the side. Fortunately, all these jobs involved animals! I was a dog walker and cat sitter for the better part of a year and worked at a friend's grooming salon on the weekends. During this period, I had a bunch of opportunities to take photos of the clients' animals. I'd stick around for a few minutes after the walk to snap some

pictures of the dog or settle in for a longer home visit with the cats. It made a huge difference when I began to compile all my work.

Not all of us have the luxury of working in an animal-related field, so I'd suggest offering low-cost shoots to friends. Don't feel compelled to give them every image you take, but be sure to provide them with some digital files as a thank-you for access to the model. You can also volunteer at a local rescue and snap photos there. You'll get a wide variety of animals in a single visit, but you'll just have to be careful about the surroundings. They probably won't look quite as homey as photos in an actual living room would.

Once I had built up a decent-sized portfolio of photos, I created an inexpensive website and threw them up there with some details about who I was and my photographic process. It's always a little cringey to write bios about yourself in the third person, so I had one of my friends do it for me. My website was ready, but I wasn't getting many clicks. I promoted myself to my friends and family again, started to post on social media about what I was doing, and printed out flyers to put up around town. I stuck flyers in every coffee shop, grocery store, and pet boutique in my area. It took time, but I eventually started to get some hits.

Photography isn't cheap and pricing is always a tricky subject. Have you ever planned or been part of planning a wedding? The cost of the photographer is typically higher than you would expect. I've altered my prices slightly over the years, but I continue to do my best to make it an affordable treat for those who are interested, and still worth my time. As a photographer, you have to figure in the time needed for traveling, shooting, and editing. What might seem to the client like a 1.5-hour investment is actually much closer to an entire day, or more. So we have to bill accordingly.

The rate you charge has to cover the cost of your equipment, training, and even things that you might not readily consider, like insurance. If you're self-employed, all these costs must be taken into account. I find that the sweet spot for prices depends mainly on where you live. In some cities, people can charge upwards of $1,000 for a pet portrait session, and some individuals only work with a higher-class clientele. I'm not that kind of dude, so that's not my style. I figure out the average cost of living where I am and work up my prices based on that.

As a fledgling photographer, I would start low, but not too low. You can be an incredible photographer, but if you only charge $50, there's a lower perceived value to your work, based on your fee. If you don't value your work, neither will others. Once you have built up a client base, or a strong social media following, you can be more selective. Here's another thing you can do instead of client shoots: License your beautiful photos to advertising agencies. If you can hook up with a photo agent or a company that hosts stock images, that's a fabulous way to make passive income.

VOLUNTEERING

Now that we're basically masters of cat photography, I want to draw attention to some significant causes that could use our help. There are a bunch of ways in which we can use our newfound skills for good in animal welfare, but I believe the most profound difference you can make is to take photos at your local shelter or rescue. Without question, better pictures of the animals in the shelter system translate into increased adoption rates. If you adopted your animal, do you remember what their intake photo looked like? Or, if you found them online via a service or the shelter's website, do you remember what picture was used?

Most of the time, the shots that are taken of shelter animals are terribly unflattering. Now I do not mean to criticize shelters and rescue organizations for this. Animal welfare organizations are already stretched to the limit in terms of time and resources. Making sure that their photos are white-balanced and cropped correctly simply isn't as critical as some other forms of lifesaving work they could be doing. It's not their fault that their shelter intake photos are bad, and they could really use our help with photography (and social media).

If you're interested in helping out locally with photography, the first thing to do is find out what shelters and animal rescue organizations are in your area. You can just type your city's name and "animal shelter" into Google. The vast majority will have some sort of website for their organization, with information about their hours, capacity, ongoing adoption events, and the like. Look for a section about volunteering. If they don't have anything readily apparent, find a list of contacts for the organization. Once you locate an email address for someone like a volunteer coordinator, drop them an email like this:

Hi <organization name> !

My name is Andrew, and I'm an amateur photographer and a lover of animals. I've heard there's a need for better photography at shelters, and I'd love to donate my time to help out taking and processing intake shots and content for social media. I look forward to hearing back from you!

Super basic and straight to the point. If, for whatever reason, they don't have a contact email listed, just give them a call and ask to speak to someone about volunteer opportunities. Mention that you'd like to help out with photography and ask what the procedure is for new volunteers. If getting someone on the phone is difficult, just go in! You'll likely have to attend a volunteer training seminar, but they usually don't take long and will help you get comfortable with the protocol. You might even make some new friends! Any volunteer is worth their weight in gold to a rescue organization, but those with a skill like photography are incredibly valuable.

Depending on how advanced their marketing department is, they may already have a social media presence. Leveraging social media to get the word out about specific animals or adoption events they're holding is a critical asset these days. If the shelter you're working with doesn't have one yet, suggest that they create one and offer to contribute to it. Apply the tips from the social media section coming up, and you'll see a marked uptick in the attention the shelter receives.

One quick word of caution if you're getting into the social media side of rescue organizations: The rescue world can be tough. Hundreds

of thousands of animals are euthanized every year in shelters in the United States. I feel like it's vital to focus and place our energy where it's doing the most good and is most effective.

If you've been around the cat social media world for any length of time, you've seen that there are many ways to get your message across. I would actively discourage you from typing in all caps frantically about animals that are on the euthanize list. Your audience is going to be very diverse, and not everyone will be in your town, your state, or even your country. It's crucial to keep the followers you have, so while you have to be realistic about your situation, you can still present the information in a calm way that doesn't devolve into a guilt trip. That doesn't work.

For the rest of this chapter, I'm going to give you some tips specific to photographing in a shelter setting. This is a bit different than just showing up at someone's house or taking photos of your own cat; you will need to employ a lot more patience and utilize some special techniques to get the shots right. But don't fret: You can take incredible photos in seemingly impossible places. You just have to know what to do.

When you show up to the cage of a new cat, you'll want to remember everything from the first chapter's section on reading cat behavior. Knowing how to approach your new subject will be critical to the photos you take. If you're too forceful with an unfamiliar cat in the shelter system, and they bite or scratch you, you may have severely complicated their chance to make it out. So it's really, really important for you to be patient, and, when given the signal to back off, you read it and comply.

Something that I strongly suggest above all else is to ask if you can either open the cage to expose the cat, or if you can bring them to a socialization room, provided they have one. Many shelters have an area where prospective adopters can meet and play with an animal. If this is available, this is an excellent opportunity for you to be able to showcase a cat's true behavior. If they don't have one, see if you can find a spot in the shelter that you can turn into a makeshift photo studio. All you need is a blank wall, but if you don't have that, you can invest in some construction paper and tape up some sheets to make a cheap backdrop. Designating an area of the shelter to take photos can make your job a whole lot easier, as the lighting and settings you'll need to apply will be consistent throughout the shoots.

There's a growing movement in the animal welfare community to change the way the bars are placed on cages. Many progressive shelters have done away with bars altogether, favoring see-through plexiglass. Others now feature see-through slats or, if there are bars, they're only horizontal. Seeing a living being in a cage is a huge bummer. It looks like a prison, and it shouldn't. We, as potential adopters, have a harder time imagining that animal in our home, and we have very little opportunity to observe their distinctive behavior.

If there's still no space where you can take them from their cages, or if it's against protocol to handle them, we still have to do our best to showcase them in the best way possible. Much of the time, the light in shelters is poor, so be ready to bring an external light source with you, like one of the ones we talked about in earlier chapters. Whether this is a flash or a ring-light, make sure you have something to help illuminate the shots, especially if you're photographing animals in cages. Light is going to be a precious commodity, and you'll need to squeeze the most out of your battery power to make it work.

If you're working with a flash, even that sometimes won't be suffi-cient, due to the geometry of cages and shelter blocks. You will need to figure out the very best way to angle the light so that it can go into the

recessed enclosures. I have found that bouncing the light up and behind me is a reasonable way to get some increased brightness. If you have an assistant or someone to help you handle the animals, you can ask them to hold a reflector behind and to the left or right. Bouncing the light off a reflector can send it into the cage, brightening the scene. If you have a ring-light or an LED, it'll be a more straightforward process: Just hold or place the light closer to the animal so that you're shining some additional brightness on them.

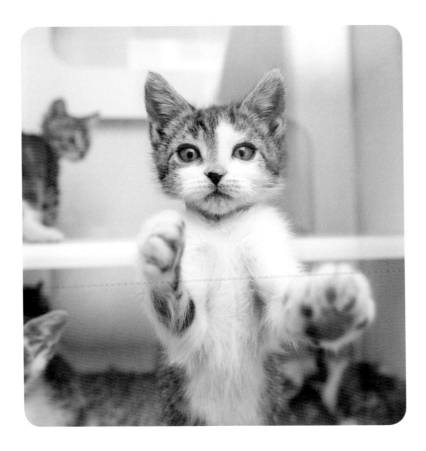

Cats appear much more presentable without bars!

Any time we can reduce the barriers (literally) between adoption and an animal staying in the shelter system, we should opt for those changes. If the photos we place online look like the picture on page 202, we're not doing our jobs right.

We need to show the world the cat in a different light, revealing their real personality. So get them out of their cages or, at the very least, open those cages so you can shoot without bars being in the way. It makes an enormous difference in the quality of the photo.

My last quick tip is something I picked up recently. Before or immediately after every shoot with a new animal, take a photo of their information sheet with the camera that you're using. For some reason, I used to write this info down and, without fail, somehow miss a cat's name along the way every time. When you have all their information in one place, it'll help streamline the editing and file-naming process.

If you foster at home, taking well-curated, beautiful photos of your fosters will be a game-changer when it comes to getting them adopted.

Watching them grow is so rewarding!

So cute, right?! I take photos of the kittens we foster almost every day. It's a ton of fun, and it's a great way to chronicle their growth and development. This enables you to build a strong narrative on your platform. The kittens will grow up. Showing that gradual process is a delight to follow along.

Kitten young to kitten older

When you foster, you see cats at their most uninhibited. Just as with your own cat, you'll be able to get shots that you wouldn't otherwise have if they had been at the shelter. Showcasing their personality is key to making adoptions happen.

SO YOUR CAT WANTS TO BE A SOCIAL MEDIA STAR?

I wouldn't classify myself as a social media mastermind, but I have been cultivating and building a social media profile for the better part of a decade. I am a member and a founding part of an incredibly fast-growing community of cat lovers on the internet. Since joining the ranks of social media eight years ago, I have shared almost 4,000 of my photos, each one with a caption or a story. Some of these are long-winded and captivating; some are just a handful of clever words and nothing more. Many of my photos have been viewed and shared millions of times, gone viral, and have been used as memes. So I'd like to think I have some insight into what content people find engaging.

Through trial and error, I've learned what works and what doesn't. And, in more recent times, how sharing beautiful photos of cats can translate into much more than just making someone say "Awww" halfway across the world. I genuinely believe you can reach people on a very deep level by sharing photos of your animals, in a way that just sharing pictures of yourself cannot.

Your pets are your best friends and, in some ways, an extension of your being. Normally, only you would be able to experience the full range of their emotional experience and behavior. If you permit it, however, social media can offer an exceptionally intimate peek into your

world, where others can take a seat and come along for the ride. People gravitate toward this unique connectivity. I feel that this is what keeps people sticking around, year after year. I have many followers who have stayed with me since I first began posting cat photos, and many of them have become my close friends. It has been a remarkable journey!

I don't mean to freak you out or sound too grandiose. Social media most definitely doesn't have to encompass anything profound or daring. It can be ridiculous and carefree. Just know that you can cultivate your online presence in any way that brings you happiness. I think that having fun and enjoying yourself are of paramount importance. Why else would we participate? However you choose to proceed with your life on the web, I have some advice and guidelines that I think will make your stay more rewarding.

From the Heart

I want you to make posts that are meaningful to you. I'm not talking about always blowing the horns of triumph, or spilling your guts until you run out of space in the caption, or intricately describing moments where the sun rises just as butterflies flutter across your face and kiss your forehead. Nah. I'm just talking about posts that "speak" to you. If you really want to stick around for the long haul, you're going to have to develop a style that works for you and is enjoyable to keep up. We all fall into ruts, and breaks are essential to ongoing posting, but if you intend to produce content for the foreseeable future, the process has to come naturally.

Early on, find the "voice" of your authorship. Just as in this book, I had to decide in the beginning how I was going to relay all this information. I could have chosen to be much more formal and conservative, or write it the way I give workshops and speak to friends. You can also choose to write in the voice of your cat. I'll be honest: That's a little cringe-inducing, but that's up to you! If you think you'll get more mileage out of your social media presence by referring to yourself in the third person as a humom and misspell words (Why do cats have such a tenuous grasp of the English language?!), then go for it.

The voice on my social media platforms is basically just me, slightly edited for mass consumption, but sometimes I throw in a thought from one of the cats featured. It can be a fun way to switch things up when your posts are getting stale. But I always, always, always post or share things that are genuine to me. It's not a chore or an errand to tick off each and every day. It's something I like doing!

By posting from the heart, I'm also showing my humanity. So much can get muddled behind screens. We often become faceless usernames. I'm not saying you have to use social media as a digital diary, but by being open and honest, it allows others to connect with you. We can smell inauthenticity from miles away. Not only are you doing a disservice to what you put out in the world, but you're not being honest with yourself. It's just a waste of energy. I think so much of this boils down to Just Be Real!

Be Creative

The posts that do the best on social media are those that aren't typical, everyday shots and captions. This probably goes without saying, but feel free to mix it up a bit. Add some flair to your photos by introducing new concepts, props, or subjects. Make your captions distinctive. The commentary under your photos is one of the most critical aspects of social media. That can sometimes be far better than the actual image. Undoubtedly, our cats have a wide range of emotional states, but it is really enjoyable to project our own emotions, thoughts, or feelings onto them. This is known as anthropomorphizing, or ascribing human characteristics to a nonhuman animal or object.

I should buy a bigger boat.

I don't often put hats on cats, but, if I do, I make it count. If you're really struggling to find your voice and generate creative content, that's okay. Let me offer you some fundamental guidelines. For example, if the photo you're going to post is of your cat having breakfast, see if there isn't a more clever way to say, "Tony is eating his food." While informative, this is boring as hell. Fluff it up.

- The few remaining shreds cry out as Tony eats the last of their kind. #silenceoftheshreds

- Chonkmaster Tony just can't get enough of his wet food.

- Good to the last bite!

- Is Tony half empty or half full? Apparently both, always. #neversatisfied

- Tony is so funny when he eats! He is by far the least graceful cat I know. Do any of your cats have fun food rituals?

- JFC. WHAT A MESS. TONY, GET IT TOGETHER, DAWG.

See? There are so many ways you could caption the same photo and evoke way more emotion from the audience than just by describing what people already see. Be mindful that, as you continue to build your social media profile, you're really curating a gallery. New people follow my page all the time, and it's so gratifying to have a body of work that they can endlessly scroll through and still enjoy, irrespective of how long ago the photos and captions may have been posted.

Be Fun

There's an overabundance of terrible news, day in and day out in our lives. The human condition is a pretty sad one, let's be honest. It's imperative for me to provide an outlet to others (and myself) of a timeless, judgment-free zone that doesn't bog anyone down. I do my best to keep things positive and to share uplifting messages. If there's something tragic that happens, because loss is a big part of the animal rescue world, I try not to dwell on it for too long on the internet. I think it's incredibly important to process our emotions and grieve for as long as it takes. There's no right or wrong way to feel your feelings, but I personally don't find it necessary to broadcast them to relative strangers for longer than a day or two.

We've lost several kittens in the time that I've been helping run an orphan kitten rescue. It's devastating when that happens, but we always try to spin it into action. In 2019, we lost a two-week-old kitten due to a congenital defect over which we had no control. We were understandably upset, but made it clear to the audience that there were things that we (and they) could do to help prevent the loss of future kittens. We encouraged people to take action in their community and help sterilize the neighborhood cats. So, it's not all rainbows and roses, but we like to keep it moving, even in the dark times. Positive messages resonate so much more deeply than negative ones.

Be Consistent

We all have a lot going on, and social media ought never take precedence over real life, but I'd like to encourage you to be consistent with your posting. The way algorithms are working these days, they tend to favor pages and individuals who post more frequently. You have a much greater chance of getting your content seen by others if you make it a point to post at least once every few days. I try to post at least once a day. Some days will be chock-full of content, and I'll post a few times throughout the day. Some weeks will have a bunch of gaps. I think as long as you're staying reasonably committed, it shouldn't be a problem to post at least once every other day.

Consistency also means sticking to a similar theme. I'm guessing most of you intend to post a lot about your cats, but if you find your preferences deviating, and you start posting about, say, 1920s replica weaponry, you can rest assured that your followers are going to be scratching their heads and wondering what happened to the cat photos. You can include some cross-interest content that will appeal to a small subset of your audience, but don't neglect the primary purpose of your page. You'll hemorrhage followers immediately, and unless you can tie in your other theme with cats, you might as well start a separate page for that hobby.

Hashtags

I think the use of hashtags is a little outdated and underused now. In the past, it was a great way to search for other users with similar content or to be a part of a hashtag group. If I were to click #photography on a post, I'd be sent to a gallery full of users who put that hashtag on their photo, and who take photography seriously. Nowadays, you'll find literally anything under any hashtag. It's gotten way oversaturated with nonsense, to the point that if I look up #cat, while I might find a bunch of photos of cats, I'll also find pictures of shirtless bros, TV shows, sports teams, and twerking videos. Not exactly what I was looking for.

More prominent hashtags like #cat or #photography have been diluted far too much to be useful. If you pinpoint or narrow down your hashtag a bit more, however, you have a better chance of finding what you're looking for. The only two hashtags I look for with any frequency are #calicocats and #catsoncatnip. Two of my loves.

You can still use hashtags and apply them to your photos. When I started out, every picture of mine had a dozen or so hashtags, and they can still work. I just wouldn't move heaven and earth to find the most meaningful hashtags for your shot. The way I use hashtags now is as a continuation of the caption. I usually use them as a punch line to the joke set up by the caption, or as an additional funny quip to accompany the main text. You can utilize the hashtag to give another perspective, or as a narrative thread to your thoughts or inner life. Hashtags work really well this way, in my opinion.

iamthecatphotographer When you knew full well you didn't need that 6th slice of pizza, but went for it anyway. #ivemadeahugemistake #thatsyourbigboy

Story Time

In my experience, the posts that garner the most interest are those that have a strong narrative accompaniment. This is another component of "finding your voice" on social media. Obviously, you're not going to be able to pull a Pulitzer Prize–winning tale out of your pocket each and every day, but when you can fluff up the material and create something compelling, do it! People absolutely love following a story line.

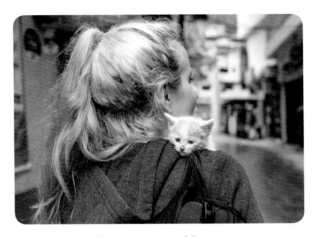

On the streets of Peru.

This photo is one of those cases. If it hasn't been made clear yet, my partner and I do a lot of rescue work. It can get extremely emotionally taxing, and in order to keep our mental health in check, we are fortunate enough to be able to take breaks. We don't have typical jobs; although we don't have a strict timetable we adhere to, we're essentially always working. So, usually once a year, we plan an international vacation where we disconnect and recharge our batteries. We went to Peru in 2017 and had a wonderful time rejuvenating our spirits. While we were there, we were so surprised by how few cats we saw during the trip. Then, on our last day before leaving to come back to the States, we

encountered a very sick, emaciated kitten. What transpired next was a 24-hour flurry of vet visits, transportation accommodations, flights, and customs clearances.

At the time of the kitten's rescue (we named her Munay), we posted online asking for help understanding travel policies and potential entrance issues related to bringing a foreign animal to the United States. We received valuable information and gave updates to our following as we could. After an exhausting day of traveling, we were eventually cleared to enter the States with her. We made sure to update those who were following along on the internet immediately. People had said they were glued to their phones, refreshing our pages to see if there had been any news. It was a compelling story, and the narrative we built around the rescue proved to be of interest to hundreds of thousands. And now Munay is a happy and healthy two-year-old cat living in Philadelphia.

Themes

Developing a recurring theme for your social media profile can be very effective. I wrote a book called *Cats on Catnip* that started as a theme for a photo shoot. I found that my roommate's cat made the craziest faces while high on the stuff, so I began snapping freeze-frames of him. The results were hilarious. I then tried my luck with other cats and captured their bizarre experiences with the green stuff, too. Before I realized it, I had accumulated a small series of photos sharing a similar theme. My followers knew to look for it on my page and to expect it in the future. Your theme doesn't have to be catnip, of course, but by developing an idea consistently, you can build a following around that concept.

There are pages of cats in hats, cats edited into photos of foods, cats as historical figures, and so on. You can also work on developing a very stylized aesthetic in your posts. A lot of brands do this. They'll have all their photos taken and edited in a specific way. When you cruise through social media, it's easy to spot these and that can work in your favor if done effectively.

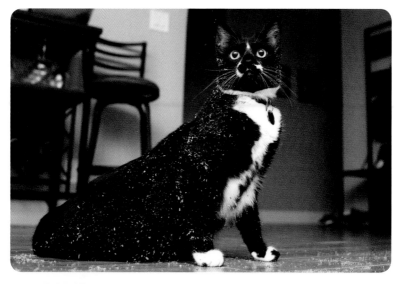

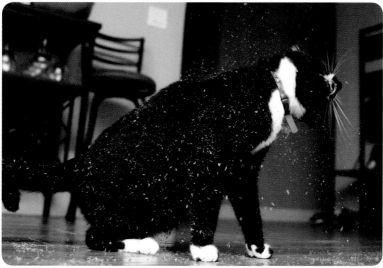

Shake it off!

If You Build It, They Will Come

Last, but certainly not least, build your community! Unless you some-
how become an overnight viral star, you're going to have to trudge
along gradually with the rest of us. My following came through years of
hard work and consistency. I didn't ever, ever anticipate that the love
for my cat and photography would develop the way it did, but here we
are. I trusted the process and loved what I was doing. It became more
natural and more enjoyable as time went on, and having an audience to
share my content with made it even that much more valuable to me.
So I persevered. I remember hitting 1,000 followers and thinking what
a monumental, and truly bizarre, moment that was. I have right around

half a million now, and although that's small potatoes to some, it's still absolutely crazy to me! I built it, and they came.

I would really like to stress the importance of engagement here, too. I don't just put photos on the internet and log off for the day. I find so much value in talking to people who follow me or are in similar circles and rescue communities. And engagement is a two-way street for me. I try to show that I value my audience as much as I can, not only by being real with them but by answering questions and extending a helping hand. My partner and I get more direct messages than we could ever realistically answer, but we do our very best to be present for the community we've helped build. You have to remember that your followers, fans, and supporters are just like a relationship that needs to be maintained. The stronger the connection you have with those around you, the more likely they are to invest their time in your content.

So, just before you close down your app after basking in the likes and comments your latest post has received, make it a point to pay it forward. Find someone whose content you like and let them know. Express positivity. Use the golden rule when composing your comments. We're not talking about deeply religious or political viewpoints—these are cats! Do your best not to criticize and instead celebrate those you think are doing well. Social media is like a slow cooker that simmers what we put into it. If we fill the pot with nonsense and negativity, we're going to bake ourselves a big old crap casserole. And no one wants to eat that. Rather, build your community, maintain your community, and protect your community. I believe in you!

Conclusion

I know we're coming to the end of this book, but I'd rather treat this as a new beginning. If you've spent time reading through this, you're now armed with brand-new skills that can be used to show off your cats' good sides (let's be real, they're all good sides), as well as leverage your photos to change the conversation when it comes to cats.

One of the reasons I am so very passionate about what I do is that when I take a photo, I'm changing the way cats (and animals in general) are being represented and understood by humans. I firmly believe that when I share my photos, I'm ultimately boosting our collective understanding and connection with felines. And I do my best to showcase a whole slew of cats on my social media channels to represent different cats in various circumstances. From cats less than one day old to cats in their mid-20s. Black, white, calico, one-eye, no tail, indoor, feral, in a home in the United States or on an island in Japan—you name it. They are all given representation. The more diversity you see, the more your empathy and compassion can grow for populations you may not have understood or even knew existed.

Humans are visually inclined learners. Through your photos, you might inspire a coworker or a family member to adopt a cat. You might become interested in changing a local law or ordinance about TNR (trap, neuter, release) in your area. You might encourage others to interact with their cats more often. You might begin fostering so that you can save lives and have a revolving door of models to photograph. You might turn someone's day around with a cute photo, or maybe Fluffy will go viral and become the next big internet star. There are so many effects, and effects of effects that we may never fully realize simply by picking up our cameras and taking photos. And that's what it's all about. And, hey, who knows? Maybe you'll end up borrowing a professional camera from your roommate for a few trial photos on your cat . . .

Acknowledgments

First and foremost, huge thanks to the cats for 1) existing and 2) putting up with me long enough to take their photo! As for humans, my sincerest gratitude goes to all those who support me, either in person or online—friends, family, and otherwise. I want to extend an additional heartfelt thanks to my partner in life, Hannah. You never stop motivating me to improve, and yet love me even when I wear sweatpants for three days straight. Also, big thanks to my agent, Lindsay Edgecombe, and editor, Jordana Tusman at Running Press, for believing in this fun and whimsical project, as well as to designer Josh McDonnell and copy editor Diana Drew for all their hard work in making the book what you see today.

Index